DERBY

From Old Photographs

DENIS EARDLEY

AMBERLEY

Acknowledgements

Several people have assisted me in my research and presentation of this book and I would particularly like to thank Nick Tomlinson for enabling me to use the Picture the Past Archive and John Hollinshead for his help and support.

First published 2017

Amberley Publishing
The Hill, Stroud
Gloucestershire, GL5 4EP

www.amberley-books.com

Copyright © Denis Eardley, 2017

The images on the front and back cover are courtesy of
Derby City Council / www.picturethepast.org.uk

The right of Denis Eardley to be identified as the Author
of this work has been asserted in accordance with the
Copyrights, Designs and Patents Act 1988.

British Library Cataloguing in Publication Data.

A catalogue record for this book is available from the British Library.

ISBN 978 1 4456 7152 9 (print)
ISBN 978 1 4456 7153 6 (ebook)

Origination by Amberley Publishing.
Printed in the UK.

Contents

Picture the Past

Picture the Past is a not-for-profit project that aims to make historic images from the library and museum collections across the whole of Nottingham, Nottinghamshire, Derby and Derbyshire available via a completely free-to-use website.

In the past, anyone wanting to view these collections would have to travel many miles to track down the ones they were interested in. This proved to be frustrating and time-consuming for researchers and a barrier to anyone from further afield. It was also damaging to the more fragile images from all the handling (the collections include hundreds of thousands of photographs, slides, negatives, glass plates, postcards and engravings).

Thankfully senior staff in the four local authorities got their heads together to solve the problem and came up with the idea of conserving them using digitisation and making them accessible via a website, which also opened the collections to anyone anywhere in the world.

Work on digitising the images started in 2002 and by 2016 over 115,000 photographs, postcards, engravings and paintings had been added to the website. Photographic copies of the images can be purchased online and, as a non-profit-making project, money raised from these sales goes back into conservation of more pictures.

You can visit the website for free at www.picturethepast.org.uk.

Derby Local Studies and Family History Library,
Riverside Chambers,
Full Street,
Derby,
DE1 3AF.

www.picturethepast.org.uk

Picture the Past

makes historic images
from the library & museum
collections of Derby,
Derbyshire, Nottingham
& Nottinghamshire,
freely available at the
click of a mouse button.

Derby City Council

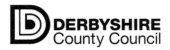

DERBYSHIRE
County Council

Introduction

There have been numerous changes to Derby's landscape over recent years, but it still retains many of its fine Georgian and Regency buildings, as well as other important edifices. Derby Cathedral, visible from a considerable distance, dominates the skyline of the Cathedral Quarter with its impressive Perpendicular tower. The stature of Derby as an important city in the UK was acknowledged when the Cathedral Quarter won the prestigious Great British High Street award in 2016.

In medieval times, Derby grew in importance as a busy centre of trade, attracting people from other towns and outlying villages. Derby's first market charter was not particularly detailed, but the second, granted fifty years later in 1204 by King John, was much more precise. This charter allowed a weekly market, held from Thursday to Friday evening, and granted the burgesses the right to levy tolls from the traders, as well as punish thieves. Later additions to the charter gave the rights to hold fairs at Easter, Whitsun and Michaelmas.

During the last 300 years Derby has grown into a major industrial city, having acquired city status in 1977. It is now ranked as one of the UK's leading hi-tech cities and the opening of Infinity Park in 2016 will further enhance Derby's position as a hi-tech leader. Research also completed in 2016 by London online company Quality Formations declared Derby as the UK's business start-up capital.

Derby's major industrial breakthrough came when, after several failed attempts to produce fine-quality silk thread, John Lombe acquired drawings of the equipment used by the Italians. Assisted by his half-brother, Thomas, he set up the Silk Mill, which was built in 1717/18. He died in 1722 – many believe he was poisoned by a woman sent by the Italians to exact revenge for stealing their secrets. It was the first factory in England where all the processes were carried out under one roof and utilising one source of power. It is now a World Heritage Site. The foundation arches and part of the tower from the 1717 mill are still visible.

The most significant change in Derby's history took place on 30 May 1839, when the first railway train steamed into the town. The excited crowds watching the train's arrival little realised how this event would alter the face of Derby. Originally, three railway companies operated from the station, but this created cutthroat competition. In 1844 the problem was solved when they amalgamated to form the Midland Railway. Large numbers of workers from all over the country were attracted to the town by the hectic activity. In 1851 records showed that 43 per cent of the adults in the town had been born outside the county.

Derby's reputation as an industrial town was boosted even further with the arrival of Rolls-Royce at the beginning of the twentieth century. The latest development in the city has been the successful development of Pride Park, on land previously used by the railway industry, which is now being followed by the Infinity Park development on the southern side of the city.

This book will be of value to those readers who have always taken a keen interest in Derby's history, providing many vivid nostalgic memories of how Derby has developed over the years. It will also be of particular interest to more recent newcomers and visitors to the city, the book having been divided into six easily identifiable trails to enable readers, if they so wish, to view the areas and points of interest mentioned on foot.

Cathedral Quarter I

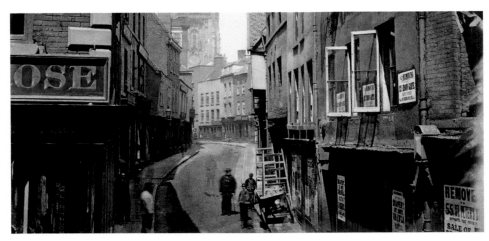

Iron Gate pictured in 1866. Three years later the demolition and widening of the street started. The shops and inns on the eastern side were rebuilt over a period of twenty years in a wide variety of styles. Frequently referred to in the past as the Regent Street of Derby, it still retains an important role in city life. The suffix 'gate' is from the Norse word '*geata*', which meant 'street' in their language – street of the iron workers. (Image Courtesy of Richard Keene Ltd / www. picturethepast.org.uk)

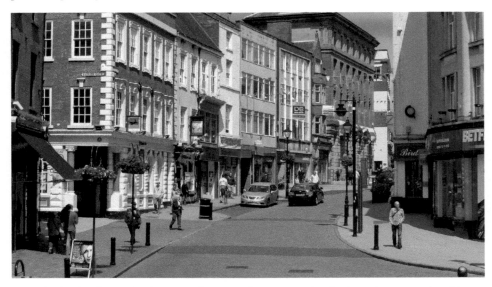

In 2009, the Academy of Urbanism, whose members are top-level urban planners and architects, short-listed Iron Gate as one of Britain's greatest streets. Recognition by such a significant national body gave testament to Derby's growing stature as an important city in the UK and at the same time increased awareness of the Cathedral Quarter as an important area with its own special identity. This was reinforced in 2016 when the Cathedral Quarter won the prestigious Great British High Street award.

Barlow Taylor's store decorated for the visit of Elizabeth II during her Silver Jubilee. The art deco building was erected in 1925. After closure it served as the main branch of the Derbyshire Building Society until 2004. In 1971, when Rolls-Royce crashed, the former Derbyshire Building Society's head office was in Iron Gate and record crowds queued outside to remove their savings, mistakenly thinking the building society had invested in Rolls-Royce, which it was not permitted to do. (Image Courtesy of Derby City Council / www.picturethepast.org.uk)

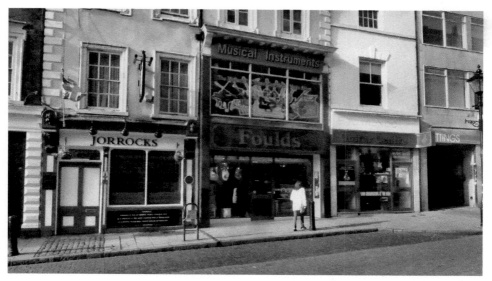

The frontage of the former George Inn is now taken up by Jorrocks public house and Foulds music shop. Charles Foulds opened his first shop in Nottingham in 1893, the present shop in Iron Gate being opened in 1908. In the centenary year for the business, Foulds' Derby shop acquired the next-door premises to open a guitar shop. This has become renowned particularly for its acoustic and jazz section and holds one of the largest collection of jazz guitars in the UK.

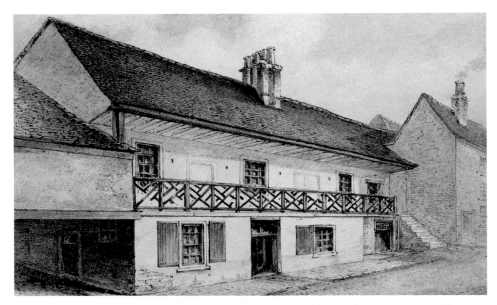

The George Inn, pictured *c.* 1920, was built around 1648 and during that era was one of the most famous and busiest coaching inns in Derby. The London to Nottingham stagecoach ran from 1735, and from 1766 the post office coach also ran. In Elizabethan days, the yard at the rear was used for theatrical performances. Notoriously, it was also the venue for cockfighting and a balconied extension was built so that patrons could watch that and other events. (Image Courtesy of Derby Museum and Art Gallery / www.picturethepast.org.uk)

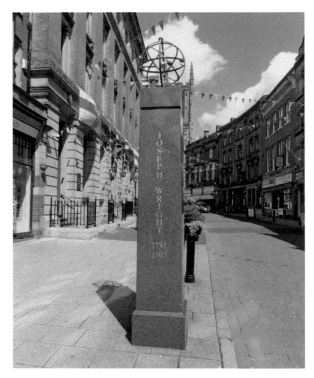

The marble memorial pillar opposite Wright's birthplace depicts an Orrery, a mechanical model of the solar system, which is featured in one of his most famous works. Today Wright is held in the highest regard both locally and internationally. There is an art gallery devoted to him at Derby Museum. His paintings hang in the National Gallery in London and in the Louvre, Paris. He was educated at Derby Free School in St Peter's Churchyard.

In 1734 the store started life as an ironmonger's shop, under the name Weatherhead, Walters & Son. However, in 1864, George Bennett bought the company and expanded the product range. The present store is actually two buildings joined into one. Part of the building previously served as a theatre, hence the rather striking staircase and imposing balcony. In a recent advertising campaign, Bennetts claimed that it was the oldest department store, not only in Derby, but the world.

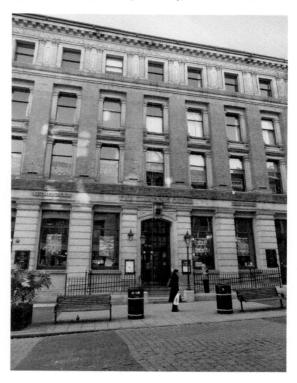

Iron Gate House was built by Samuel Crompton in the early eighteenth century; his father founded Derby's first bank in 1685. The ground floor was used as the family bank until 1880, when another bank, the Crompton & Evans Bank, was built next door. Eventually both banks amalgamated and became the Crompton & Evans Union Bank, which was later absorbed by NatWest. It is now a Wetherspoon pub, rather appropriately named the Standing Order (pictured here).

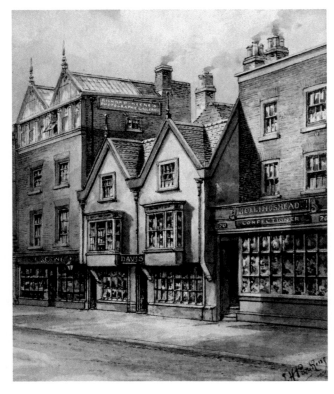

The former home of John Whitehurst is on the left in this pre-1936 picture. Born on 10 April 1713, he became one of the foremost scientists of his day and a founder member of the Lunar Society. He was best known as a clockmaker and invented the round dial longcase clock. Later the premises were used by Richard Keene as a photographer's studio. He won thirty-four major awards and took commissions from the royal family. (Image Courtesy of Derby Museum and Art Gallery / www.picturethepast.org.uk)

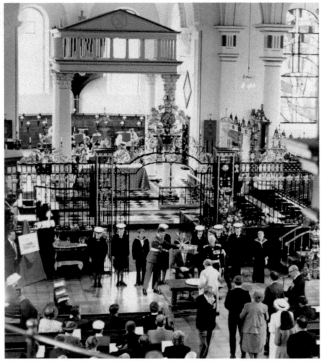

This picture features the Spirit of Derbyshire Lifeboat Appeal Ceremony, 1990. The cathedral is exceptionally beautiful inside and visitors are encouraged to walk round, to sit and enjoy the atmosphere and to join in worship if they so desire. Many interesting features and monuments are to be found, including Bess of Hardwick's monument, Joseph Wright's tombstone, the Bakewell Screen and much more. In 1978 the outer part of the Cavendish burial vault was converted into a small crypt chapel. (Image Courtesy of *Derby Evening Telegraph* / www. picturethepast.org.uk)

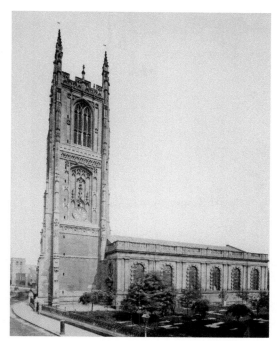

Visible from a considerable distance, Derby Cathedral dominates the skyline with its impressive Perpendicular tower. It became a cathedral in 1927, with the hallowing of All Saints' Church, pictured *c.* 1875. The church was built early in the sixteenth century, but worship has taken place on this site since the tenth century. The tower, at 212 feet, is said to be the second highest in England, and it has the oldest ring of ten bells in the world. (Image Courtesy of Derby City Council / www.picturethepast.org.uk)

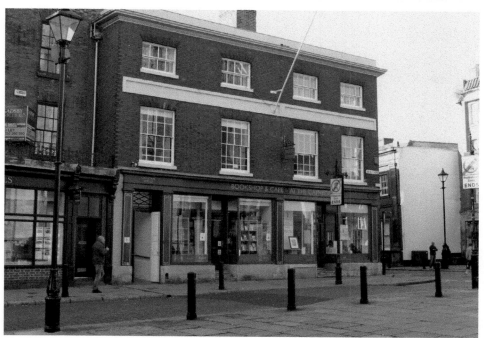

The Cathedral Centre was opened by Her Majesty the Queen on her visit to Derby on 14 November 2003. Located in what was once Clulow's bookshop, it boasts a highly acclaimed café and the only Christian bookshop in Derby. The café is a past winner of 'Best Tea/Coffee Shop' in the Derbyshire Food and Drinks Awards. In addition, the Cathedral Centre also provides a place to host meetings and events.

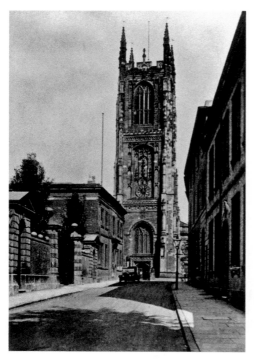

St Mary's Gate, seen here in the 1930s, took its name from the ancient church of St Mary, one of the six churches in Derby recorded in the Domesday Book. The church stood on the corner of St Mary's Gate and Queen Street, almost opposite what is now Derby Cathedral. A rather narrow street, it is one of Derby's most important historic thoroughfares, containing many fine buildings. Traditionally known as the home to legal practices, numbers have declined recently. (Image Courtesy of Derby City Council / www.picturethepast.org.uk)

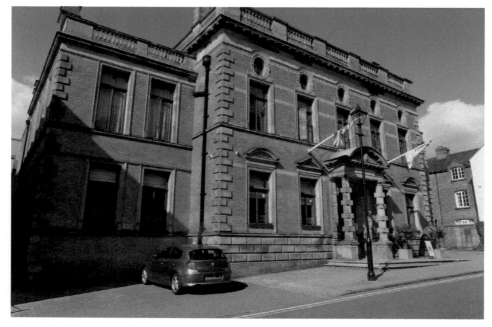

The Cathedral Quarter Hotel was originally built as council offices, and also served as the Police Museum before becoming a hotel. Opened in May 2008, its sympathetic conversion rates it as one of the finest hotels in the county. In 2010, it enjoyed royal patronage when Her Majesty the Queen dined at the hotel on Maundy Thursday. She had presented pensioners with Maundy money at Derby Cathedral, in what was believed to be the 800th anniversary of the ceremony.

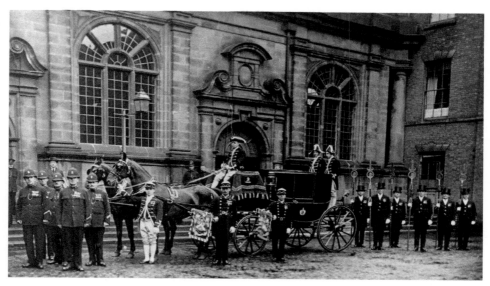

In the mid-seventeenth century, St Mary's Gate was selected as a suitable place to build a shire hall, which later became known as the County Hall. Originally it was used for concerts, plays and gatherings, as well as courts and assizes. Assize courts were ceremonial occasions, as pictured, and originated in the reign of Henry II. They were courts with a judge and jury and sat with the authority of the monarch, bringing the king's justice to the people. (Image Courtesy of *Derby Evening Telegraph* / www.picturethepast.org.uk)

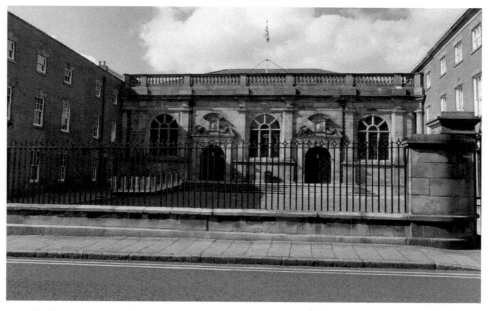

Initially, the assizes for both Derbyshire and Nottinghamshire were held in Nottingham. From 1328 joint assizes were held alternatively in Nottingham and Derby and then separately from 1566. In 1714, when the new Assembly Rooms were built, the buildings in St Mary's Gate became exclusively a Crown Court. An inn was added on one side around 1795 and judges' lodgings on the other side in 1811. The courts closed in 1989 and have been converted into the city's Magistrates' Court.

Boden's Pleasance was a small green donated to the people of Derby by the widow of Henry Boden. He was a lace magnate and member of the Temperance Union and benefactor, who died in 1908. The park opened two years later and had wrought-iron gates decorated with Boden's crest. The gates are still there at the front of Parksafe car park, in Bold Lane. Boden's Lace Mill produced 22 million square yards of mosquito netting during the First World War.

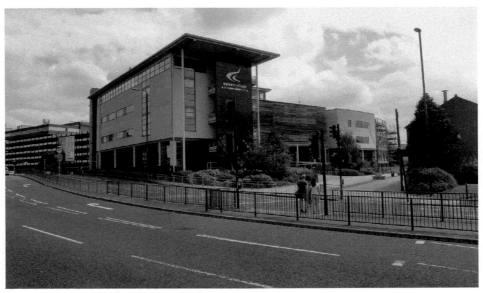

The £12-million Joseph Wright Centre in Cathedral Road is part of Derby College and follows the merger of Mackworth, Broomfield and Wilmorton Colleges. The name originates from the internationally famous local artist whose work in the mid- to late eighteenth century was inspired by scientific and technological art forms. The building's high-impact design produced by local architects is unique to Derby and covers four storeys. It has been extended to provide more study and social space for the students.

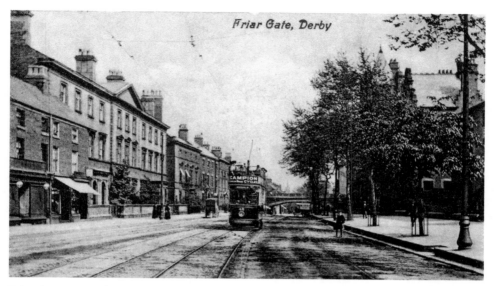

Friar Gate, pictured *c.* 1900 looking towards Friar Gate Bridge, is one of Derby's most ancient streets and has retained many of its older buildings. Gell's House is a fine example of a seventeenth-century townhouse. The Friary Hotel is built on part of the land once occupied by a Dominican monastery, dating back to the sixteenth century. St Werburgh's Church, on the corner of Cheapside and Friar Gate, has been rebuilt many times but is no longer in use. (Image Courtesy of Derby City Council / www.picturethepast.org.uk)

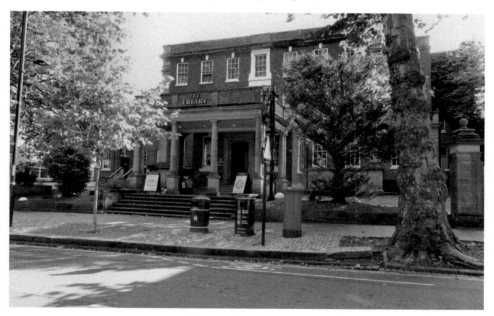

The Friary Hotel was built on part of the grounds that once belonged to a Dominican monastery. Here a large friary was erected with approximately 16 acres of parkland, featuring fishponds, a chapel and other buildings. On his father's death in 1725, Samuel Crompton took over the family's banking business and this provided him with the capital to build the friary. It was extended in 1760, 1875 and in the 1950s and is now a hotel.

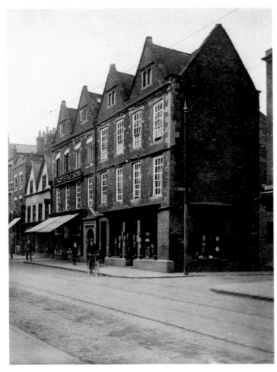

Gell's House, pictured in 1920, is Derby's finest surviving complete seventeenth-century town house. The four-storey gabled building was the Parliamentary headquarters during the English Civil War. It was probably built for Col Thomas Gell, the brother of Sir John Gell, the notorious governor of Derby during the war. The Gell family lived at Hopton Hall for nearly 500 years and were the dominating influence in the area before the hall was sold in 1989. (Image Courtesy of C. B. Sherwin / www.picturethepast.org.uk)

The former Derby Gas, Light & Coke Co. showrooms and offices used to operate from the premises pictured. Built in 1889, the name of the company can still be seen on the wall of this fine Victorian building. The first public gas lamp was lit in the Market Place on 19 February 1821. Twenty years later, an Act of Parliament allowed Derby Gas Light & Coke Co. to supply customers outside the borough, leading to further expansion.

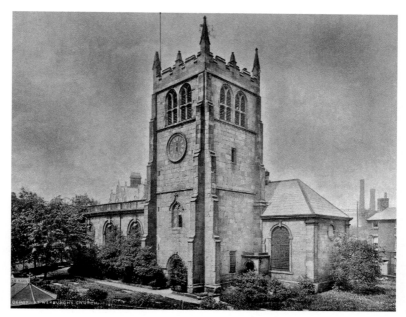

St Werburgh's Church, pictured in the 1890s, closed for worship in the 1980s and later opened as a shopping gallery, but this venture was not a success. Later efforts to develop it as a Chinese restaurant also failed. The tower was rebuilt in Gothic style between 1601 and 1608. The chancel built during the 1690s retains much of its contemporary woodwork and furnishings, including Bakewell's superb iron font cover. A trust cares for the tower and the old chancel. (Image Courtesy of Derby City Council / www.picturethepast.org.uk)

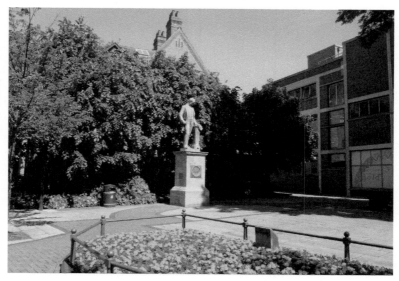

Michael Thomas Bass was a member of the Burton brewing company that bears his name, an MP for Derby and a benefactor of the town. He paid for the construction of the library and museum and funded the open-air baths and adjacent parkland by the River Derwent. The library and museum was built in 1876–79 and is of Gothic design with a Franco-Flemish tower and Arts and Crafts detailing, including wrought iron by Edwin Haslam around a frescoed gallery.

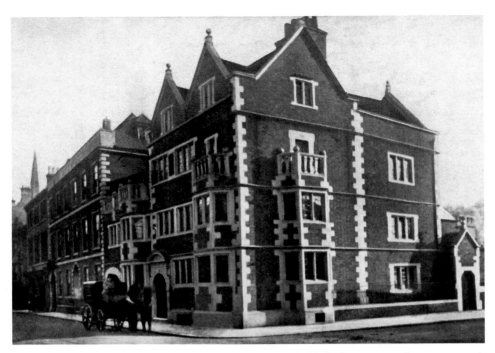

Acclaimed as the finest Jacobean house in Derby, it was probably built in 1611 and was once much larger, having five gables and the grounds extending to 2 acres. It was later sensitively reduced in size to make way for Becket Street. It still remains a magnificent decorative building, despite being much diminished in size. Built of red brick, it was the first brick building to be built in Derby. The picture dates back to 1900. (Image Courtesy of Derby City Council / www.picturethepast.org.uk)

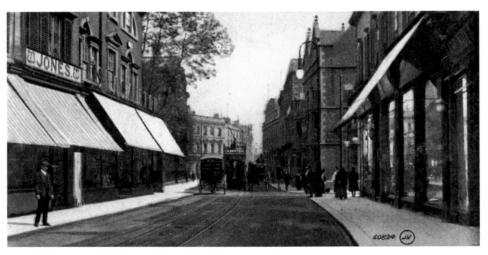

The c. 1908 view pictured is of The Wardwick looking towards Victoria Street, with Becket Street in the middle distance on the right. Further along on the same side, after the shops, behind what is now the Wardwick Tavern was a brewery. In the 1930s it was demolished to make way for a telephone exchange, replaced forty years later. The premises fronting the street were used until the late 1960s as brewery offices, before they were turned into a pub. (Image Courtesy of Derby City Council / www.picturethepast.org.uk)

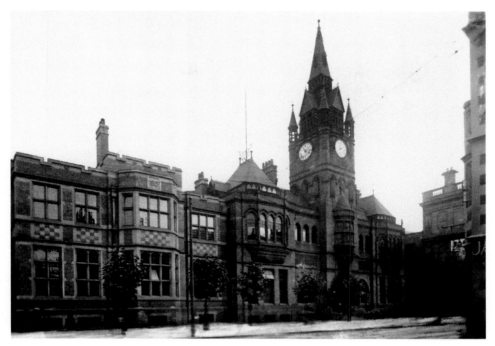

The Free Library and Museum, pictured *c.* 1920, showing the extension added in 1915, when the curator's house alongside the library was demolished to house the recently acquired Bemrose Library. A further extension was completed in 1965. The museum houses the internationally famous Joseph Wright gallery and a large display of Royal Crown Derby in the Ceramics Gallery, together with an award-winning coffee house. Further displays include archaeology, natural history, geology and military collections. (Image Courtesy of Derby City Council / www.picturethepast.org.uk)

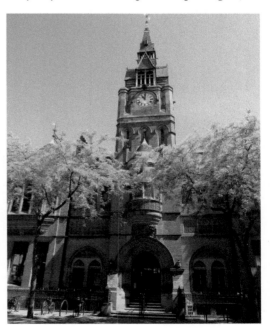

Before the Public Libraries Act of 1850 was passed, the libraries in existence in Derby were generally operated by booksellers on a subscription basis. Derby Borough Council did not immediately take advantage of the powers conferred by the new Act. However, in 1878, the Duke of Devonshire donated a collection of books and papers to the borough, and a year later, in a building donated by Michael Thomas Bass, the Derby Free Library and Museum was opened.

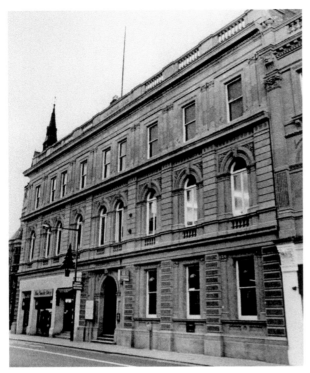

Founded by Joseph Strutt in 1825, the Mechanics' Institute was open from early in the morning until 10 p.m. There were classes for reading, writing, arithmetic, drawing, music, French and chemistry for adults, as well as a weekly class to discuss literary and scientific subjects. The library contained nearly 6,000 volumes and newspapers, and periodicals were provided. The Institute had a number of famous visitors including Charles Dickens, the author and actor, and Franz Liszt, the Hungarian-born pianist and composer. (Image Courtesy of *Derby Evening Telegraph* / www. picturethepast.org.uk)

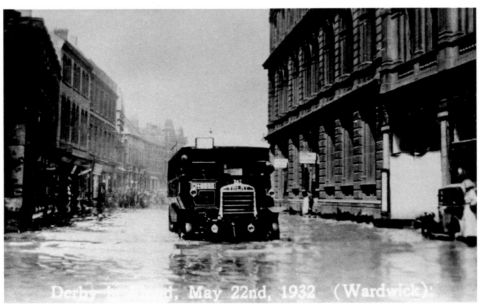

22 May 1932 saw catastrophic flooding in Derby. Markeaton Brook burst its banks, causing a great deal of damage and businesses to lose a considerable amount of stock. An iron plaque is fixed to the front of the Wardwick Tavern that marks the level the floodwaters reached on 1 April 1842; subsequent raising of the street level reduces the true impact of the sign. This flood level, though, was exceeded in 1932. (Image Courtesy of Derby City Council / www.picturethepast.org.uk)

Cathedral Quarter II

Sadler Gate, pictured *c.* 1950, unlike Iron Gate, has not been widened and is now virtually traffic free. It probably originated as a route to the Wardwick and Ashbourne Road and beyond, when the market place was first developed around 1100. The street takes its name from leather workers, not only saddlers but bags, boots and shoes. There are several yards off Sadler Gate with George Yard running almost parallel with the street before emerging close to Sadler Gate Bridge. (Image Courtesy of Derby City Council / www.picturethepast.org.uk)

Sadler Gate links Iron Gate with Bold Lane and The Strand and is a hive of activity during the day, with the emphasis on shopping and refreshment. Evenings are a transformation when the clubs, bars and pubs attract crowds of fun seekers and diners. The street has become much safer since being pedestrianised. It is far older than it appears, as is revealed from the rear of the buildings, the fronts having been modernised.

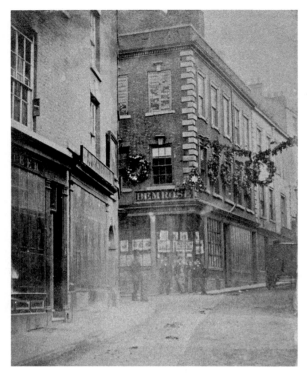

The house on the top corner of Sadler Gate was probably built around 1695. It later became the shop of William Bemrose, who in 1840 employed a staff of twelve at his printing and stationery business. It remained in the same location until 1903, housing the bookshop and accounts. The main business moved to Wellington Street with the award of the contract to print Midland Railway timetables and stationary. The 1856 picture features peace celebrations at the end of the Crimean War. (Image Courtesy of Derby City Council / www.picturethepast.org.uk)

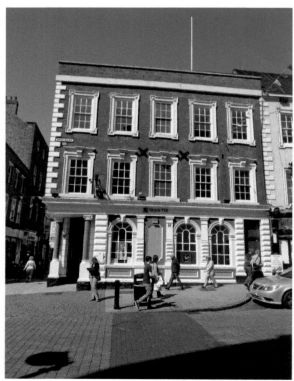

Lloyds Bank now occupies the house on the top corner of Sadler Gate. The pitched roof has been removed and replaced with a flat one. Sadler Gate Corner used to be something of an accident 'black spot'. It was a main road in medieval times and in May 1837 a lady was knocked down and sustained a broken leg. A coach with four horses failed to navigate the corner and crashed into the wall, and other minor accidents also occurred.

In 1850 twelve carpenters meeting at the Bull's Head were told by a traveller about the 'Rochdale Pioneers'. As a result of what they heard, the Derby Co-operative Society was formed based on the £2 capital raised by the twelve carpenters. They started the society by establishing a small store in a converted hayloft on the first floor of a stable block in George Yard, pictured *c.* 1900. (Image Courtesy of Jackson, J. W. / www.picturethepast.org.uk)

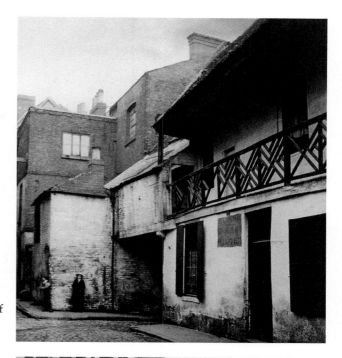

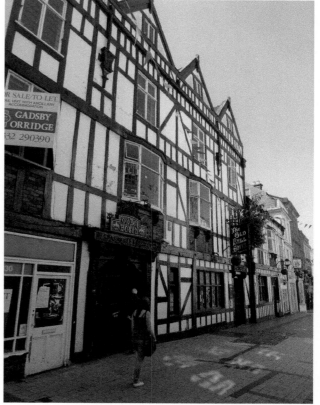

In earlier days Sadler Gate had several busy coaching inns. Minimal time before departure was allowed for passengers to seek refreshment and to change horses. The Meynell family built the Bell Inn around 1680. John Campion acquired the freehold in 1780 and during the floods of 1842, the nine-year-old grandson of John Campion II was 'launched in a wash-tub in the cellars' – the purpose, to save some vintage bottles of wine placed there by his great-grandfather.

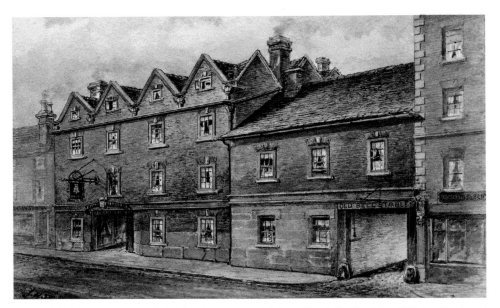

A new black-and-white mock-Tudor front was added to The Bell Hotel in 1929 by Ford and Weston, seven years after this picture was taken. The Bell was a favourite watering hole for local politicians, some of whom tried to bribe the local electorate to vote for them by providing free drinks on polling day. Those who did not have the right to vote tended to riot in disappointment – more at missing the free beer than the vote. (Image Courtesy of Derby Museum and Art Gallery / www.picturethepast.org.uk)

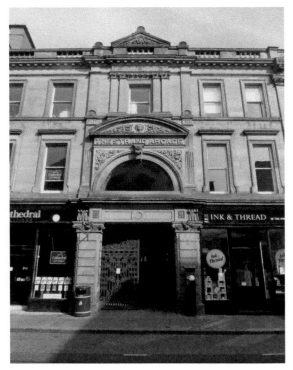

Derby's Victorian Strand Arcade was created in the early 1870s. It was fashioned to replicate London's Burlington Arcade from designs by John Story and built in 1880. It links Sadler Gate and The Strand, and has been described as 'a unique link between different ages and city cultures'. Sadler Gate, dating from medieval times, winds its way along in an informal, haphazard fashion, which contrasts with the more formal appearance of both The Strand and the Strand Arcade.

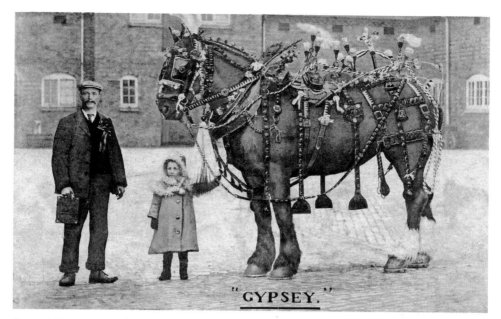

"GYPSEY."

A pre-1920 picture of Mr Dunstan, a sadler, and his daughter with a horse named Gypsey, in what was then known as Palfree's Yard. Palfree's granddaughter, a veterinary surgeon, had an animal hospital there until 1979. The yard was then redeveloped and a modified version of the fifteenth-century merchant's house, found behind the former Assembly Rooms during construction work, was rebuilt in the yard. Horses were once shod here in what is now known as Blacksmith's Yard. (Image Courtesy of Derby City Council / www.picturethepast.org.uk)

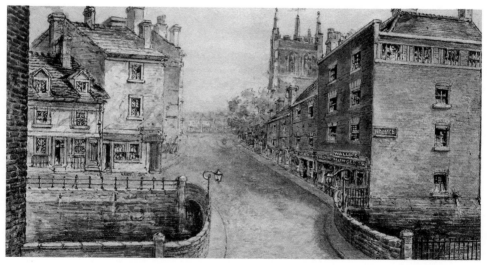

It may seem a little strange to the visitor walking down Sadler Gate to see a sign at the bottom of the street above a shop indicating 'Sadler Gate Bridge'. The bridge over the Markeaton Brook, rebuilt by William Strutt in 1786, is now covered over following the culverting of the brook in the late 1800s. This enabled a new street, called The Strand, to be formed. Originally the bridge, pictured *c.* 1900, gave access across Markeaton Brook to Cheapside. (Image Courtesy of Derby Museum and Art Gallery / www.picturethepast.org.uk)

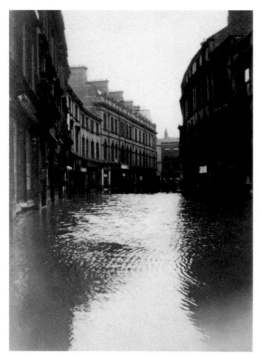

When Markeaton Brook was culverted from Sadler Gate Bridge to St James' Bridge, The Strand was formed and named after the Strand in London, which acquired its name because it originally followed the line of the Thames. The Old English word '*strand*', means 'shore'. The shallow bank of the once much wider River Thames was far closer to the street then. Sir Abraham Woodiwiss built the street in 1878–81 as a commercial venture. The picture shows the 1932 floods. (Image Courtesy of Mr Clarke / www.picturethepast.org.uk)

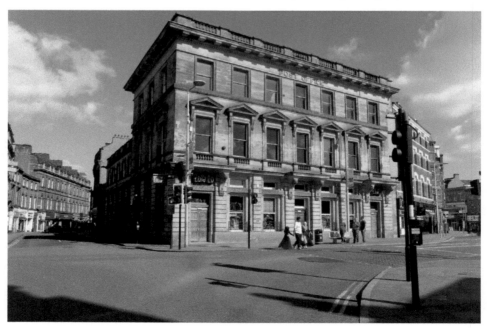

After Markeaton Brook had been culverted, St James' Lane was widened and renamed St James' Street. In 1869, the General Post Office occupied the corner site with Victoria Street, before being moved further along Victoria Street, moving again to Babington Lane in May 2013. The 1869 post office's name is still visible on the front. In the 1990s, the street closed to all through traffic and the Corn Market end was paved.

Pictured *c.* 1910 is St James' Street, which after it had been widened and acquired its present name became an elegant shopping thoroughfare. This was a far cry from the time when it had been described as 'a narrow, unsightly and unsavoury alley'. The work was paid for by the building of St James' Hotel. (Image Courtesy of Derby City Council / www.picturethepast.org.uk)

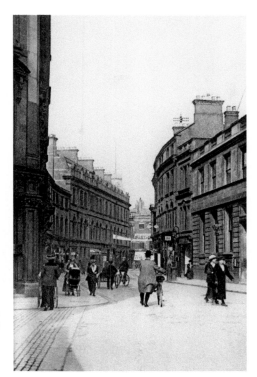

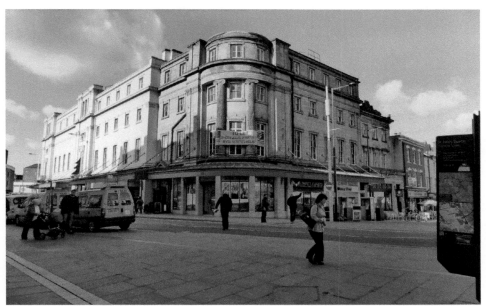

The Royal Hotel, on the corner of the Corn Market and Victoria Street, was built in 1837 by Robert Wallace after he won a competition to design it, together with the Athenaeum and a post office. He had also been selected to design the Derby & Derbyshire Bank, which was adjacent to the proposed new development. After completion, the hotel soon became the town's leading location for visitors and a popular place for public celebrations. It closed in 1951.

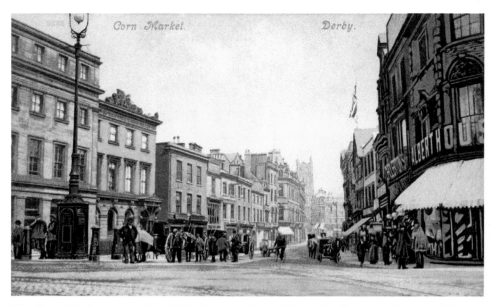

The Corn Market, pictured *c.* 1900, is noticeably wider at the St Peter's Street end. It was deliberately constructed like this so as to be able to accommodate the Grain Market. Here, merchants placed samples of grain in containers sited on posts so that potential buyers could test them. The market continued until the Corn Exchange was built on Albert Street, but the beast market moved to another site much sooner, as the animals ate the grain, causing many arguments. (Image Courtesy of Derby City Council / www.picturethepast.org.uk)

The Athenaeum Society premises adjacent to the Royal Hotel faced Victoria Street. They were the home to a news room where the latest editions of some eighteen different newspapers and journals were available for members to study. It also housed the new Town & Country Museum. On the Corn Market side of the hotel, the post office, which was part of Wallace's development, was subsequently moved to St James' Street. The Derbyshire & Derby Bank sign can still be seen.

Lock-up Yard was once the scene of the brutal murder of a policeman. On 12 July 1879, Gerald Mainwaring, after drinking heavily, set off driving a horse and trap through the streets of Derby accompanied by a prostitute. He was apprehended, and at the police station shot and killed PC Moss and wounded another officer. The sentence to hang him was mistakenly reported to have resulted from the illegal toss of a coin, which resulted in the Home Secretary commuting the sentence.

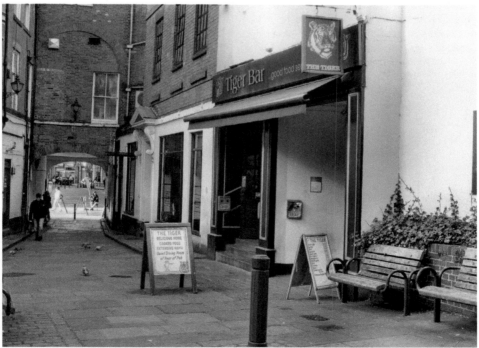

The Tiger public house dates from 1737, when it operated as a coaching inn. It was originally much larger: the frontage once stretched as far as the Corn Market. Now reduced in size, it was restored in 1990. It is a popular stopping place for parties on ghost walks, providing access for a subterranean trip down into the Derby Catacombs. It was once used to convey prisoners between the police station and the Courts of Assize, which were held at the Guildhall.

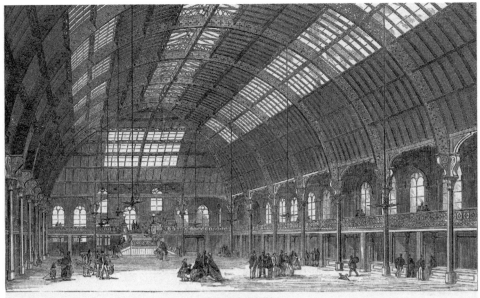

NEW MARKET-HALL, DERBY.

The covered Market Hall hides behind the Guildhall and is one of Derby's greatest treasures, a fine example of Victorian architecture with a spectacular vaulted roof, using iron supplied by a nearby foundry. Inside, there is a wealth of unusual, classic and traditional stalls and cafés. It cost £29,000 to build, and was officially opened on 29 May 1866 by the mayor, Frederick Longdon. A choir of 600 performed the 'Messiah' and there were parades in the streets. (Image Courtesy of Derby City Council / www.picturethepast.org.uk)

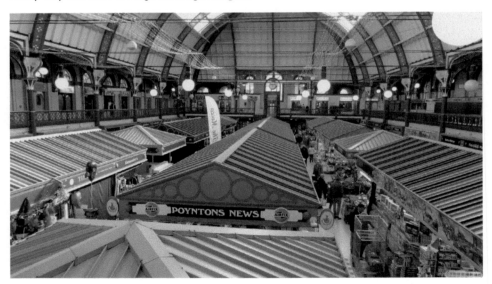

Over the years the covered Market Hall has adapted to changing circumstances and there has been a growth of service stalls. The fish market was relocated to the south side of the Market Hall in 1926 and is now sited in Lock-up Yard. The poultry market occupies an annexe. The Market Hall was closed in July 1987 for major repairs and renovation, with the intention of returning it to its original appearance as a Victorian listed building.

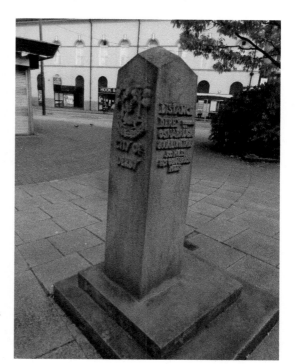

The fish market that once stood in the square outside the Market Hall was demolished in 1981 and relocated to the Lock-up Yard off the Corn Market. Today, Osnabruck Square, named after Derby's twin city in Germany, takes its place. The stone pillar announces that the German city is 500 miles away, was founded in AD 780, has many historic buildings and, like Derby, is close to beautiful countryside.

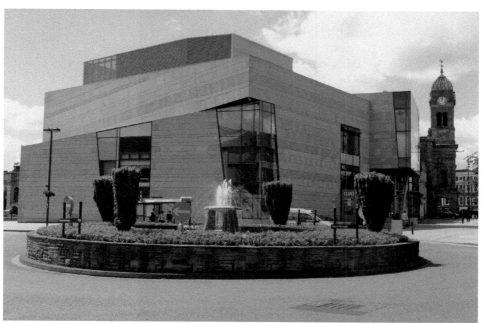

The Quad opened in September 2008 and is proving very popular with Derby people and visitors alike. It is an £11-million purpose-built centre for art and film, with a gallery, two cinema screens, café bar and workshop that anyone can hire. Quad's activities generate millions of pounds in terms of additional and direct spend with local suppliers as well as positive national and international media coverage for Derby. It is a registered independent charity.

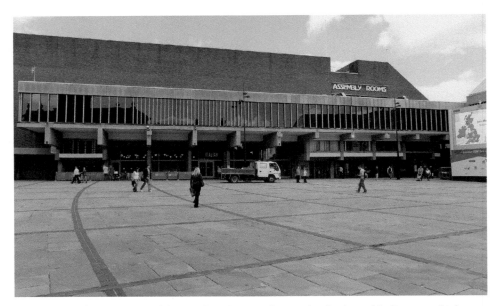

A large part of the top side of the Market Place is taken up by the Assembly Rooms, which were built by Casson, Conder & Partners between 1973 and 1977, and is currently closed following a fire. The building was designed to contain a large and small hall, with bars and coffee shops separated by spacious foyers. Part of the elaborate plaster Jacobean ceiling from the former Assembly Rooms has been preserved in the reception foyer outside the Darwin Suite.

Royal Oak House, built in 1889 as an inn, is a half-timbered black-and-white building. It replaced a former inn that was burnt down a few years previously. By 1894 the inn had closed and it was used by the council to house the Mayor's Parlour and council offices, before becoming a solicitors' office. In 2005 it won the Civic Society's award for the best-restored historic building in Derby and is now the Derby Registry Office.

On 21 October 1841 the former Guildhall burnt down, leaving only the outside walls. Henry Duesbury, a local man, was commissioned to design a replacement, which included a 103-foot-high clock tower that rang out regular time checks every fifteen minutes. At one time it was the home of the council chamber and police cells. Now the former council chamber, with its elaborately plastered ceiling, is occupied by a small theatre and concert hall. The picture dates back to *c*. 1905. (Image Courtesy of Derby City Council / www.picturethepast.org.uk)

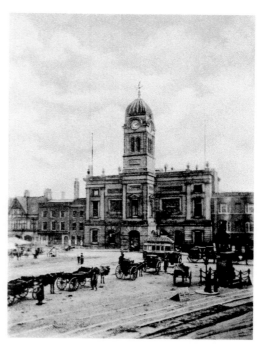

Located on the Iron Gate side of the Market Place, Franceys's House immediately attracts the eye. It is one of Derby's most imposing buildings, built around 1694 for Alderman William Franceys, a well-to-do alderman and apothecary. He was the only tradesman to be allowed to attend the very select County Assembly. An exception was made in his case, probably because he looked after the health of the county gentry. The frescoed ceilings were the work of Francis Bassano.

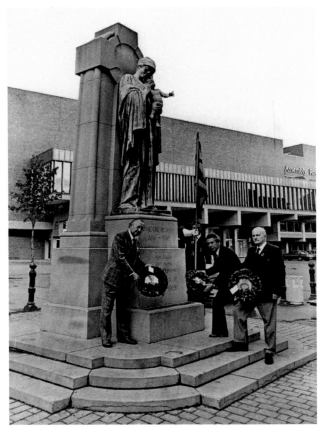

Airmen pictured laying wreaths on 15 October 1980, marking the 40th anniversary of the Battle of Britain. The war memorial is made up of bronze figures on a stone plinth with a stone cross at the rear. It was unveiled on the 11 November 1924, to commemorate those from Derby who had lost their lives during the First World War. Additional plaques have been added to honour those who died during the Second World War and more recent conflicts. (Image Courtesy of *Derby Evening Telegraph* / www. picturethepast.org.uk)

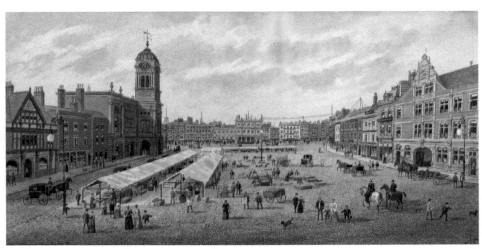

This 1894 panoramic view of Derby Market Place is the work of William Frederick Austin. Nowadays, the northern side is used mainly for events and the southern for relaxation, where visitors can sit and rest, or take advantage of the Speaker's Corner to address the public! The waterfall provides a most unusual feature and it has supplied a reason for an annual well dressing to take place. (Image Courtesy of Derby Museum and Art Gallery / www.picturethepast.org.uk)

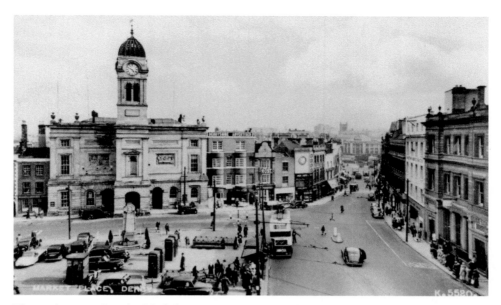

The market moved to the Morledge in 1933. For a time the Market Place was a focus for public transport, as seen in this *c.* 1950 picture, where shoppers, workers, visitors, schoolchildren and other users caught or alighted from buses. The end of vehicular access to the Market Place came in 1992, when the Derby Promenade Scheme changed the face of much of the centre of Derby. As a result the Market Place was pedestrianised. (Image Courtesy of Derby City Council / www.picturethepast.org.uk)

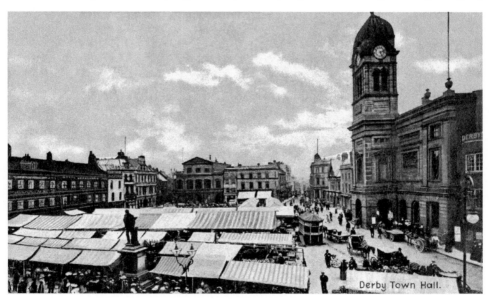

The Market Place almost certainly did not come into existence until around 1100 according to archaeological excavations. An ancient trackway used to run along the south side of where Derby Market Place now stands and was in existence many years before the town became part of the landscape. The market was a focal point, both for trade and social purposes, where shoppers and traders would exchange gossip as well as goods. The picture is *c.* 1911. (Image Courtesy of Derbyshire Libraries / www.picturethepast.org.uk)

St Peter's Quarter

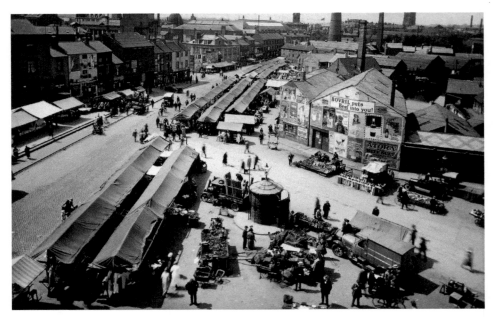

In 1154, Henry II granted Derby a charter that gave the town the right to hold markets. As a consequence Derby developed a tradition of holding a weekly market for cattle, sheep and pigs. From 1861 markets were held at the Morledge, pictured in 1929. They were then moved to the Holmes, on the northern side of what later became the bus station. Shortly after its centenary celebrations in 1962, the market moved again to Chequers Road. (Image Courtesy of Derby City Council / www.picturethepast.org.uk)

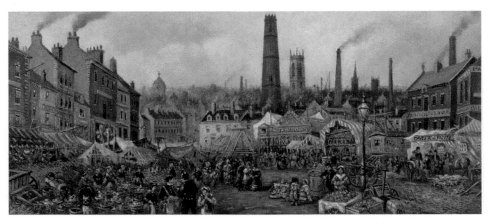

When the Morledge was widened, the popular charter fair had to go, depicted by artist C. T. Moore in 1882. The last fair to be held was at Easter in 1931 and an open market was set up two years later when it moved from the Market Place. It remained at the Morledge until the completion of the Eagle Centre, when it moved indoors, opening as the Eagle Market on 20 November 1975, despite much controversy. (Image Courtesy of Derby Museum and Art Gallery / www.picturethepast.org.uk)

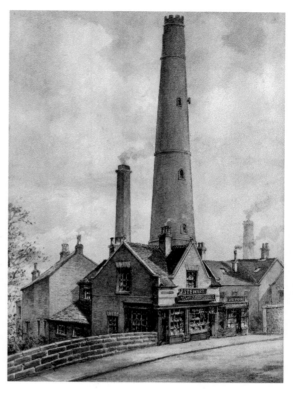

The Shot Tower was one of Derby's most famous landmarks before it was demolished in 1932, pictured by S. H. Parkins in 1925, along with Tenant Street Bridge. Molten lead was poured through a grille at the top of the tower, separating into globules and cooling as it descended, finally being cooled in a trough at the bottom. Rossons, the gunsmiths, whose business was in the Market Place, then had the shot loaded into cartridges at an isolated works in Littleover. (Image Courtesy of Derby Museum and Art Gallery / www.picturethepast.org.uk)

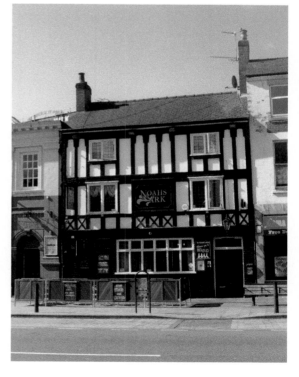

Established in the first half of the 1700s, the pub's name probably originates from Noah Bullock, a seventeenth-century gentleman who built an ark for his family and moored it on the River Derwent. Here he engaged in the illegal trade of counterfeiting coins, until he was caught and summoned to appear before Derby magistrate Sir Simon Degge. Fortunately, Noah was a friend of Sir Simon's and admitted the offence and agreed to stop counterfeiting to escape the hangman's noose.

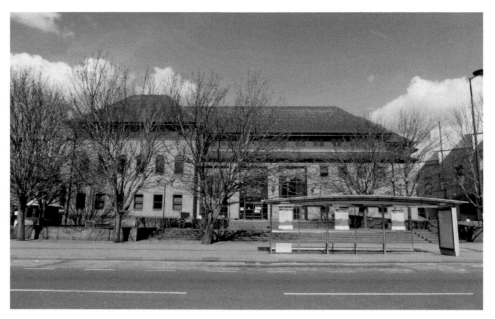

In 1989 the Crown Court in St Mary's Gate closed and was transferred to the newly built courthouse on the Morledge. St Mary's Gate had been selected, in the mid-seventeenth century, as a suitable place to build a shire hall, which later became known as the County Hall. It was designed by George Eaton of Etwall and completed in 1659. Originally it was used for concerts, plays, and gatherings, as well as courts and assizes.

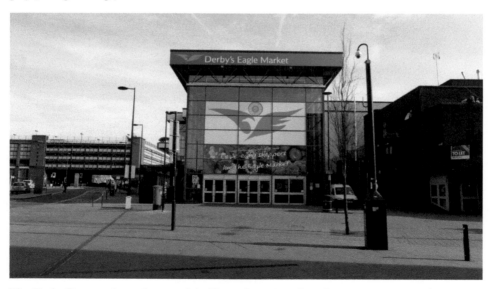

The Eagle Centre, pictured, opened in November 1975, but the contemporary style was not popular, with many shoppers complaining of getting lost. It was eventually refurbished and officially reopened on 26 June 1992, with a much more traditional design. The Eagle Centre ceased to exist in 2007 and was renamed Westfield (Intu) after the completion of a three-year project to build a new shopping centre. However, the Eagle Market was not part of the redevelopment and retained its original name. In March 2017 the market was acquired by Intu.

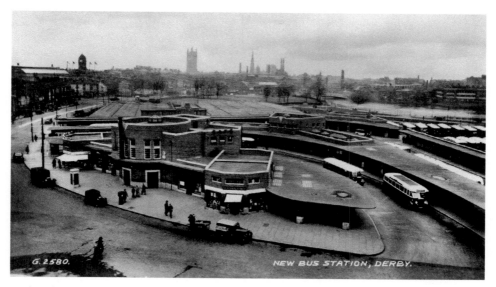

Derby's first bus station was comparatively small and located on Albert Street. It was operational from 1923 to 1933, when services were transferred to the newly built bus station on the Morledge, pictured at that time. It was designed by the borough architect, Charles Aslin, and officially opened in October 1933 despite considerable controversy among the public, who objected to the removal of other facilities. It was replaced by Riverlights in March 2010 despite further controversy. (Image Courtesy of Derby City Council / www.picturethepast.org.uk)

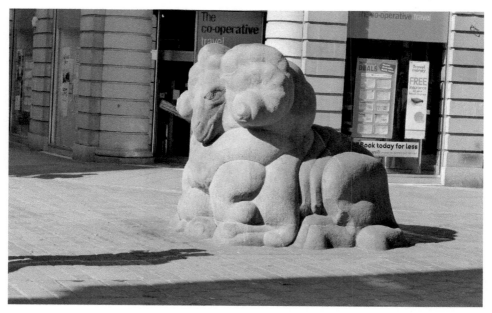

The Derby Ram statue was created in 1994 by sculptor Michael Pegler. It is an 8-foot-high sculpture in Derbyshire gritstone, erected at the corner of Albion Street and East Street, following the completion of pedestrianisation in the city centre. A ballad was written many years ago about the 'Derby Ram', who by tradition was huge and much larger than depicted by the sculptor. The name 'Rams' has been used by Derby County and the ram is a regimental mascot.

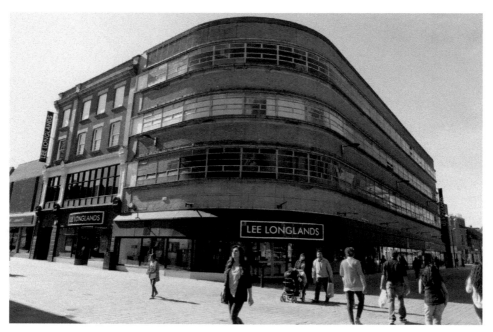

Founded in 1849, the Co-op in Derby was one of the first co-operative societies in the world. For nearly all of the 1990s, the Co-op occupied most of Albion Street/Exchange Street and the society's main department store remained in Albion Street until April 2013, when it was replaced by Lee Longlands. The Co-op offered a wide range of services and at the beginning of the last century there were sixty separate stores and departments in Derby.

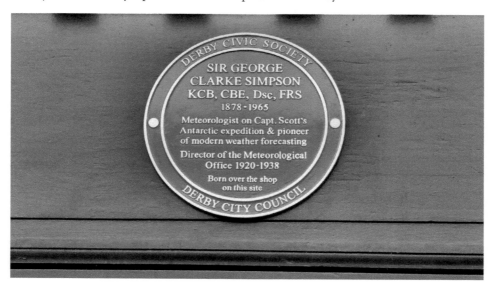

George Clarke Simpson, born in East Street, was a meteorologist for Scott's famous Antarctic Expedition. Given the nickname 'Sunny Jim' by the other expedition members, he constructed one of the continent's first weather stations. He was in command of the station when Scott and his party left for their ill-fated journey to the South Pole in November 1911. He went on to become an important pioneer of meteorology and was honoured with a knighthood for his services in 1935.

The Old Boots Arts and Crafts building is one of the city's most appealing. What particularly attracts attention are the four small statues in niches spaced out above the shop frontage. The statues are of Florence Nightingale, the 'Lady of the lamp'; John Lombe, a member of the family who established the Silk Mill; William Hutton, who published a *History of Derby* in 1791; and Jedediah Strutt, the first of a family of mill owner's and public benefactors. (Image Courtesy of *Derby Evening Telegraph* / www.picturethepast.org.uk)

John Boot, born in Radcliffe on Trent, Nottinghamshire, in 1815, founded Boots the chemists thirty-four years later. It was his son, Jesse Boot, who transformed the company into a national retailer. The company branded itself as 'Chemists to the Nation'. Boots moved from its old St Peter's Street site to a new one on the corner of East Street in 1912. The Halifax Building Society took over ownership in 1975, prior to it becoming a coffee shop.

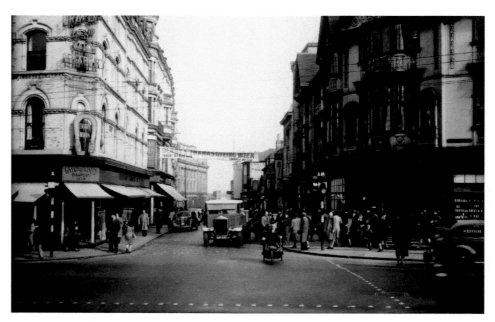

East Street was formerly known as Bag Lane and was an important route connecting St Peter's Church with the Cock Pit. This 1940s picture shows Boots on the right and the Midland Drapery on the left. The latter had a distinctive magnet symbol at parapet level on the street corner. Founded by Edwin T. Ann, who later became an alderman, it was one of the largest department stores in the country, employing 300 people in 1909. It closed in 1970. (Image Courtesy of Derby City Council / www.picturethepast.org.uk)

St Peter's Churchyard saw significant redevelopment towards the end of the nineteenth century. The whole of the north side of the street was transferred to commercial use. Buildings were purpose-built and well designed by skilled architects with plenty of attention to detail. The principal public building was the County Court, Gothic Revival in construction, with alternating bands of dark-pink brick and buff-coloured moulded terracotta. It is now known as the Old Courthouse and is Grade II listed.

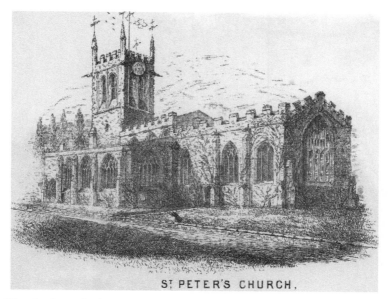

St PETER'S CHURCH.

St Peter's Church, shown in the *c.* 1800 engraving, is the jewel in the crown of St Peter's Quarter. It is the oldest church in Derby and still contains some Saxon fabric. Precisely when St Peter's was founded is uncertain, but it was recorded in the Domesday Book and may go back much further. On the pillar at the north side of the chancel arch and on the wall of the south aisle are capital letters carved by Norman craftsmen. (Image Courtesy of Derby City Council / www. picturethepast.org.uk)

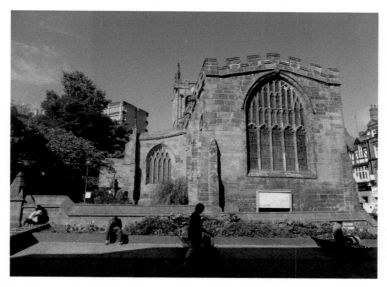

The church celebrates its birthday every year on St Peter's Day and, according to present-day thinking, it was founded in 1042. In 2010, the church raised the required money to rehouse the Florence Nightingale window from the chapel at the old Derbyshire Royal Infirmary, which resulted in a substantial increase in the number of visitors. This move became necessary as the hospital combined with the former Derby City General Hospital at Mickleover, now the Royal Derby Hospital.

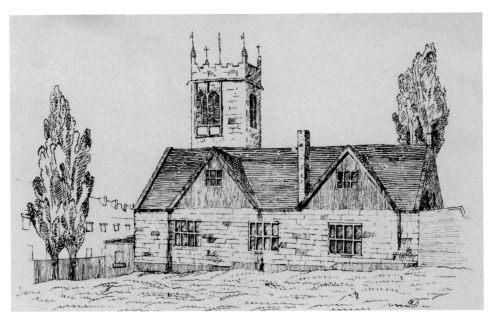

It is not known when Derby School, shown in the nineteenth-century engraving, was founded, but the first mention is in a charter of Darley Abbey when the canons went to their newly founded Augustinian monastery in 1146. Shortly after the Dissolution of the Monasteries, a charter was passed in 1554 for a free grammar school to be built. As a consequence, the Tudor building in St Peter's Churchyard was erected and used as a school for three centuries. (Image Courtesy of Derby City Council / www.picturethepast.org.uk)

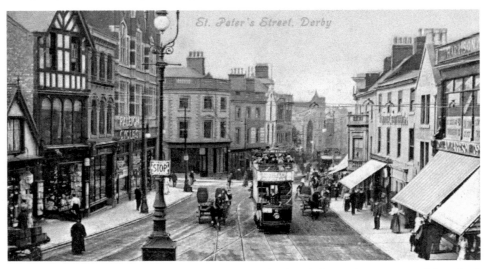

The Spot, seen here c. 1912, is a well-known Derby landmark from where it is possible to look down St Peter's Street and follow the line of the ancient north to south trackway, which existed long before the town came into existence. In the 1750s it was the point from where the new London turnpike road diverged from the old route via Osmaston and Swarkestone Bridge. Exactly how it got the name is a curiosity, although there are several theories. (Image Courtesy of A. P. Knighton / www.picturethepast.org.uk)

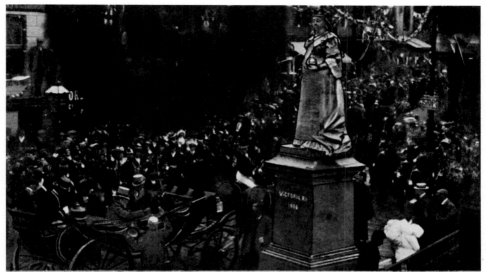

KING EDWARD VII UNVEILING QUEEN VICTORIA'S MEMORIAL DERBY, JUNE 28ᵗʰ, 1906.

The bronze statue of Queen Victoria donated by famous Derby engineer Sir Alfred Seale Haslam was originally located at The Spot. Edward VII, seen in the picture, visited Derby to unveil the statue of his mother on 28 June 1906. Queen Victoria made her only state visit to Derby in 1891, when she laid the foundation stone of the new Derbyshire Royal Infirmary and knighted the mayor, Alderman Alfred Seale Haslam, at Derby railway station. (Image Courtesy of Derby City Council / www.picturethepast.org.uk)

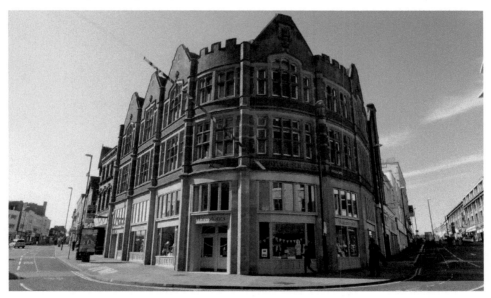

High up at the front of Babington Buildings are two baboons carved on either side of a barrel or tun – 'baboon-tun' – which interprets as Babington. The building is named after Babington House, which was built in 1626 for Henry Mellor, later to become Derby's first mayor. It was an imposing mansion, situated opposite to Babington Hall and, entered from the street through a four-centred 'Tudor' arch, decorated with three heraldic beasts set in the high perimeter wall.

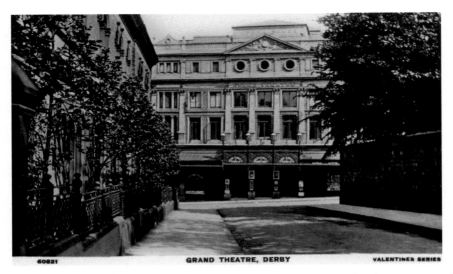

The Grand Theatre was built on land that was formerly the gardens of Babington House by impresario and actor Andrew Melville and opened in 1885. It burnt down in 1886, but was quickly replaced. Over the next sixty-four years it staged a wide variety of entertainment, including playing host to some of the biggest names in British entertainment and staged Bram Stoker's famous vampire novel *Count Dracula* before closing in 1950. The name can still be seen above the entrance. (Image Courtesy of A. P. Knighton / www.picturethepast.org.uk)

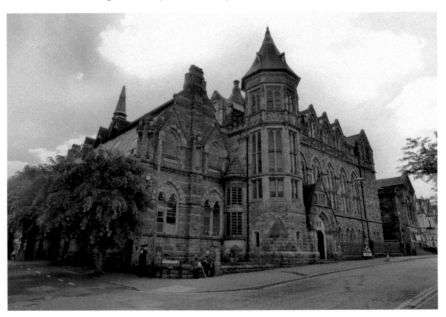

The former technical college was designed by Thomas Simmonds, the new college's principal, in partnership with his friend and former fellow student, Gloucester architect F. W. Waller, son-in-law of T. H. Huxley, the biologist. It was completed in 1876 as the Municipal Technical College and enlarged in 1894. Students studying at Green Lane have been under the umbrella of various educational bodies including the Derby School of Art, Derby College of Art and the University of Derby, prior to closure.

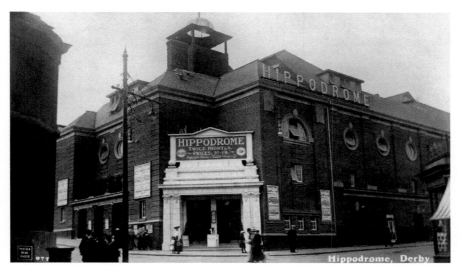

In 1913 the Hippodrome was built, pictured around that time. It opened the following year as a music hall, converting to a theatre in 1950, closing in 1959, then reopening at a later date as a bingo hall. Previously it was the site of Derby's first private lunatic asylum. Thomas Fisher, a surgeon, was the proprietor. However, after it was replaced by the County Asylum at Mickleover, it was divided into two villas, before eventual demolition. (Image Courtesy of A. P. Knighton / www.picturethepast.org.uk)

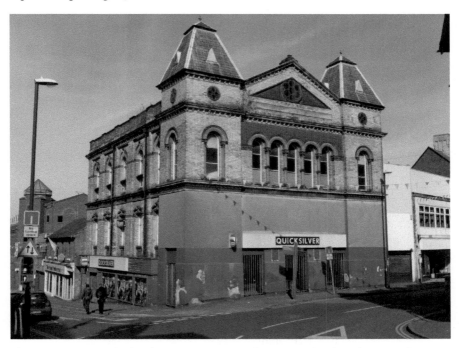

The former Primitive Methodist church on the corner of St Peter's Churchyard Street and Green Lane has lost its pinnacles, but is still a building of potential. It was built in 1878 and closed following a merger of chapels in the middle of the next century. In the 1970s it was converted into a furniture store and later a bingo hall and amusement arcade under the name of Quicksilver, but is now closed.

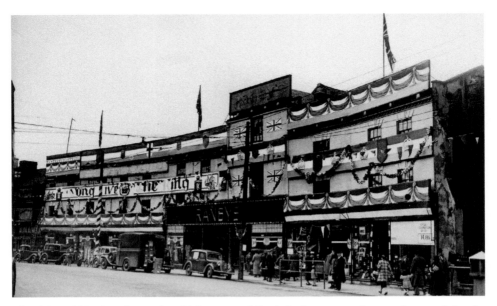

This May 1937 view shows the old frontage of Ranby's departmental store, decorated for the Coronation of George VI. It was later taken over by Debenhams, who remained until moving to Westfield (now Intu) in 2007. It has an interesting curved shaped frontage and was recently occupied by Silly Sid's furniture shop. The departure of Woolworths and then Debenhams a few years later combined to reduce footfall and diminished the street's importance as a shopping venue. (Image Courtesy of Derby City Council / www.picturethepast.org.uk)

Victoria Street marks the border between the cathedral and St Peter's Quarters, the buildings on the southern side being included in the latter. Before the Markeaton Brook was culverted the street was known as Brookside. St Peter's Bridge stood at the intersection of St Peter's Street and the Corn Market; a further footbridge led to the county gaol, known as Gaol Bridge. Following several disastrous floods for traders and people living in the area, remedial action was eventually taken.

The imposing building on the corner of St Peter's Street and Albert Street, pictured in 1974, was built in 1910 and is now occupied by HSBC Bank. Prior to the realignment of St Peter's Street in the 1880s, Thorntree House stood on the bank's site. It had been rebuilt for Joseph Strutt in the 1820s, the youngest son of Jedidiah Strutt. The narrow lane running alongside the building is Thorntree Lane, one of Derby's cobbled medieval thoroughfares that still survive. (Image Courtesy of R. E. Pearson / www.picturethepast.org.uk)

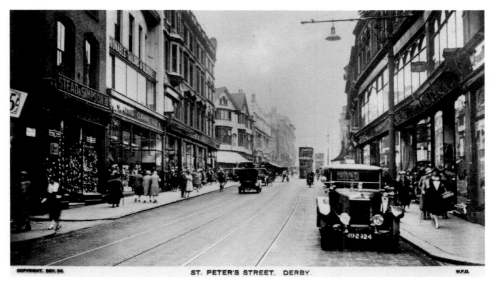

St Peter's Street, pictured before the Second World War, developed along the historic north to south route, which connected the street with the Market Place, across the bridge over Markeaton Brook. Originally the parishes of St Peter's and All Saints played football at Shrovetide. A French prisoner of war once said about the game, 'If the English call this playing, it would be impossible to say what they call fighting.' The game has been abolished, but Ashbourne still continues the tradition. (Image Courtesy of A. P. Knighton / www.picturethepast.org.uk)

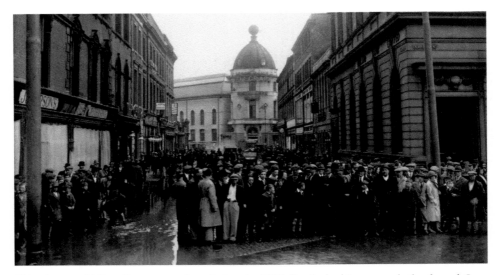

This picture of Albert Street was taken during the 1932 floods, looking towards the domed Corn Exchange, which was built in 1861 following long-standing complaints that corn dealers were obstructing the footpaths in the Corn Market. It became the Palace Theatre of Varieties in 1897 and twenty-two years later the Palais de Danse, advertising dancing 'twice nightly'. It contained luxurious lounges, tea and supper rooms, until the *Derby Daily Telegraph* took it over for offices in 1929, before leaving in 1979. (Image Courtesy of Derby City Council / www.picturethepast.org.uk)

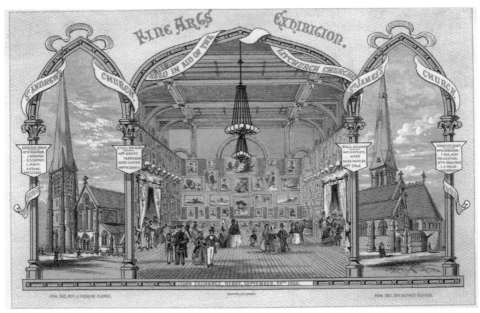

Published by William Bemrose, this is an advertisement of a fine arts exhibition at the Corn Exchange in 1866, showing the interior of Derby's Corn Exchange and the exteriors of St Andrew's and St James' churches. After serving as the Palace Theatre of Varieties and then the Palais de Danse, the dance hall closed at the outbreak of the First World War. After the war ended, it reverted back to the Palais de Danse, before the *Derby Evening Telegraph* took over. (Image Courtesy of Derby City Council / www.picturethepast.org.uk)

Upper Friar Gate and the West End

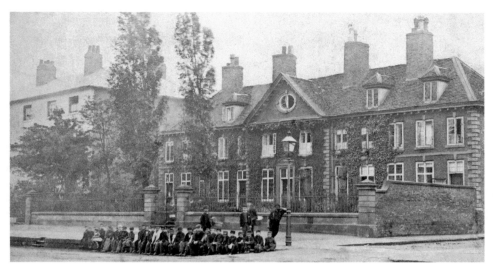

Friar Gate was the first conservation area in Derby; it was designated in September 1969, and has been extended several times. It has many interesting Georgian and Regency buildings, over a hundred of which are listed as Buildings of Special Architectural or Historic Interest. London plane trees further enhance the street, which takes its name from the thirteenth-century friary that once stood by the road in the lower part of Friar Gate. Pictured are the Clergy Widows' Almshouses, *c.* 1865. (Image Courtesy of Derby City Council / www.picturethepast.org.uk)

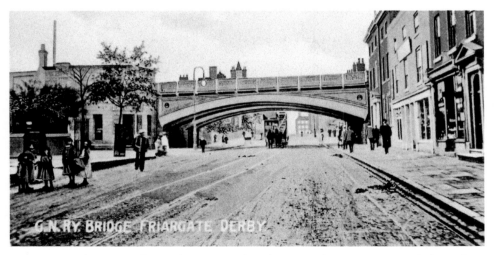

Friar Gate Bridge is actually two bridges side by side, pictured *c.* 1900, set at a slight angle to each other where the tracks diverged, to embrace the island platform of Friargate station (spelt 'Friargate' in this context) on the southern side. The bridge was built by Handysides, a local Derby company, and the first train left the station on the 1 April 1878 and the last on 5 May 1964. The final goods train passed through on 4 May 1968. (Image Courtesy of Derby City Council / www.picturethepast.org.uk)

The Great Northern Railway had the bridge constructed in 1878, despite very strong opposition. Local people were in uproar saying that the bridge would completely destroy the appearance of what they termed 'the best street in Derby'. Anger only equivalent to that a century later when it was suggested the bridge should be removed. The bridge was made deliberately ornate to try to match the handsome Georgian street below and placate the protesters. The station had four platforms.

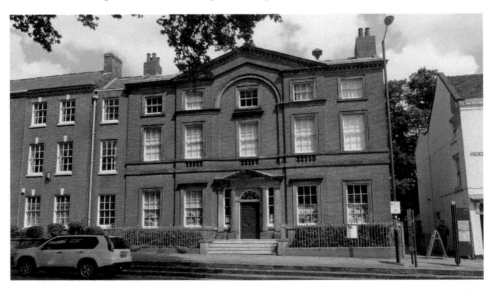

Pickford's most notable achievements in Derby were the building of St Helen's House and his building work in Friar Gate, which was not just confined to the house (pictured) he built for himself and his family between 1769 and 1770. The façade was designed to impress clients; those who entered found the hall richly decorated with ornamental plasterwork, and the house's finest room, the saloon, was where they would probably be entertained. In 1988 the house was converted into a museum.

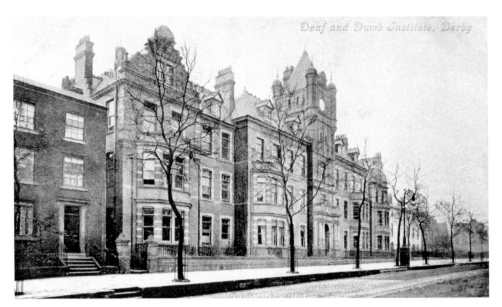

Where the Royal Institution for the Deaf and Dumb, pictured, *c.* 1900, used to stand, cast-iron slabs, illustrating signing hands, are embedded in the pavement – the communication signals used by teachers and pupils. The Elementary Education Act of 1870 made free education available and all children under twelve were expected to attend school. William Roe at the age of twenty spent much of his spare time teaching uneducated deaf adults, until the school was completed in 1894. (Image Courtesy of Derby City Council / www.picturethepast.org.uk)

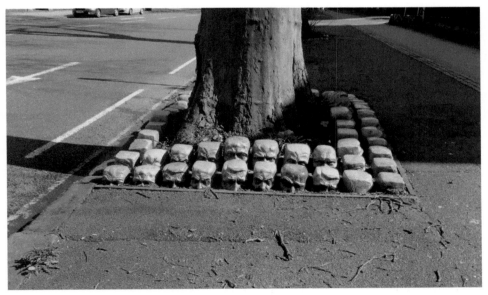

Near the front of the former Large's Hospital is a collection of stoneware heads, planted at the base of London plane trees, that have graced this elegant Georgian Street since the 1860s. The heads are intended to represent the figures in the crowds that gathered in Derby at the time of the Reform Bill of 1831 when a considerable amount of rioting took place. They were designed by Timothy Clapcott and installed in 2000 by Sustrans cycle network.

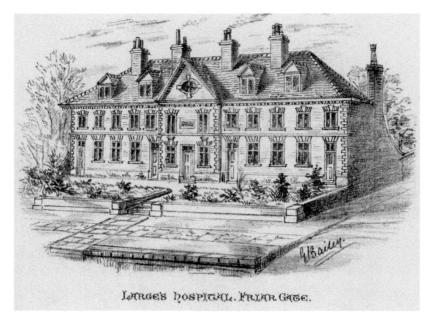

LARGE'S HOSPITAL. FRIAR GATE.

A mid-1800s image of almshouses known as Large's Hospital, founded by Edward Large of Derby in 1709, for five clergymen's widows with a small court in front and garden at the rear divided among the inhabitants. The almshouses were rebuilt in 1880 and the buildings have now been converted into offices. The rather aged panels on the front of the building set out details of Edward Large's will and the trustees for the rebuilding of the hospital. (Image Courtesy of Derby City Council / www.picturethepast.org.uk)

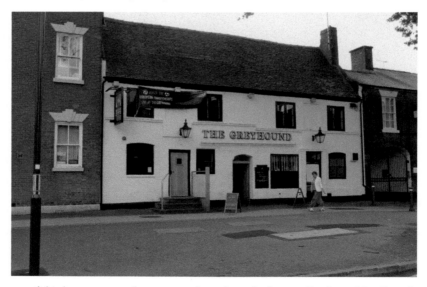

The name of this late seventeenth-century pub predates the former Greyhound Stadium that once operated nearby, from where some people think it takes its name. The greyhound was a badge of Edward IV, inherited by the Tudor monarchs and also the crest of two well-known Derbyshire families, the Blackwalls and Gells. Originally thatched, the pub is now one of only two remaining that once served the animal markets held at the end of Friar Gate.

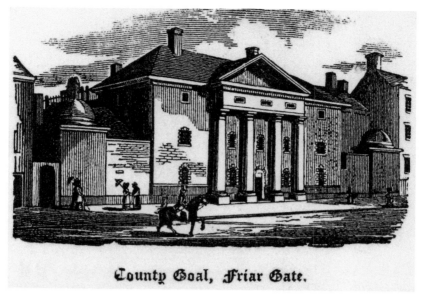

County Goal, Friar Gate.

The Corn Market gaol survived for almost 200 years, until, following numerous complaints, it was decided to build a more substantial structure away from the town centre. In 1755, agreement was reached to relocate the gaol at Nuns Green (Friar Gate). The Corn Market gaol was finally closed and the new gaol, pictured around 1826, had its first complement of prisoners. Designed to house a maximum of twenty-nine prisoners, it was soon obvious that it was too small. (Image Courtesy of Miss Frances Webb / www.picturethepast.org.uk)

In 1981 the headless cross was moved back to its present location in Friar Gate. During outbreaks of the plague, all public gatherings were discontinued. Food stuffs were left near the cross by local farmers, vigorously chewing tobacco, in an effort to prevent the spread of the disease. The hollow in the top of the stone was filled with vinegar to act as a disinfectant for the coins that were immersed by the starving citizens of Derby, in payment for food.

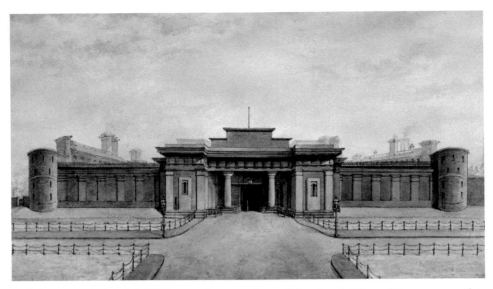

Built between 1823 and 1827, Vernon Street gaol was claimed to be 'One of the most complete prisons in England'. Following the Reform Act riots, it was strengthened and fortified with Martello towers. It was remodelled again in 1880 and later changed its name to HM Prison Derby, pictured post-1880. In 1928 the prison was completely demolished, leaving only the curtain wall and the imposing entrance. It later served as a greyhound stadium, before being redeveloped for mixed use. (Image Courtesy of Derby Museum and Art Gallery / www.picturethepast.org.uk)

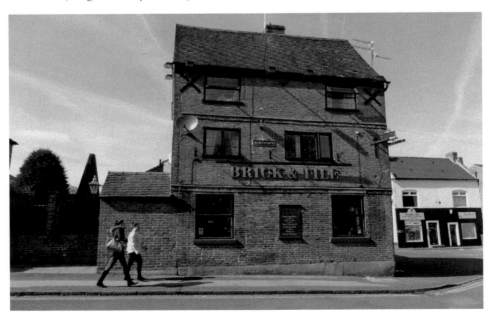

The Brick & Tile was one of several pubs that sprang up to serve the cattle market when it was held at the west end of Nuns Green (Friar Gate). The pub is located between Markeaton Street and Friar Gate and was built in the early sixteenth century. It was established as a public house sometime just before 1750, although it may have been in existence selling alcohol under a different name prior to that.

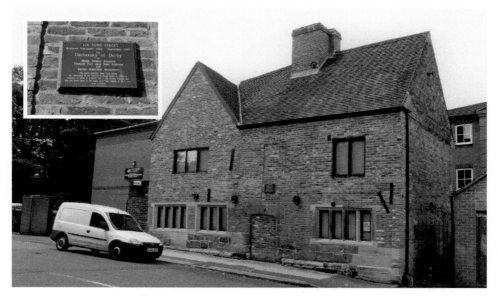

King's Mead Priory was a Benedictine priory, situated in what is now Nuns Street, and dedicated to 'St Mary de Pratis' – see the plaque on the wall. After the Dissolution of the Monasteries, the convent came under the control of the mayor and burgesses of Derby. It covered an area stretching from Bridge Street to Ford Street. After a 1768 Act of Parliament was passed, redevelopment followed, with the name of the main street changing to Friar Gate.

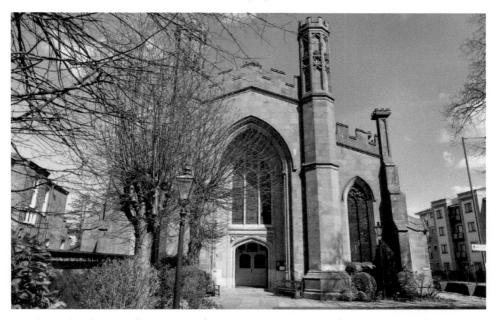

St John's Church, in Mill Street, was for many years the centre for community life in Derby's old West End. Consecrated in 1828, it was first 'new' church in Derby to be sanctified since the Reformation and is now the only surviving Commissioners' church in Derby. A Church Building Act was passed by Parliament in 1818, under which a commission was set up to provide grants of £1.5 million to build 600 churches. The churches were known as Commissioners' churches.

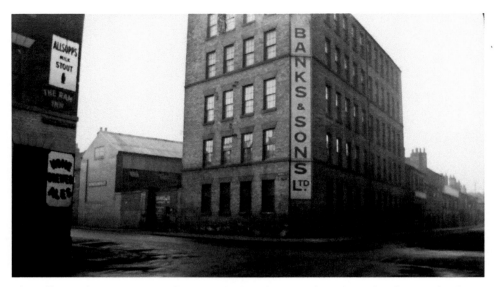

The mill in Bridge Street, pictured *c.* 1935, built in the 1860s for John and William Rickard, was one of the last silk mills erected in Derby. Later it was sometimes called the 'Elephant Works' after the trademark of Banks & Sons Ltd. In recent times the mill has been turned into studios by Derby University, who own and manage the site. The studios were set up to retain graduate-level skills in the creative industries. (Image Courtesy of Derby City Council / www.picturethepast.org.uk)

Five Lamps is a busy triangular junction of some character, with raised flower beds on the Belper Road side. It forms a meeting point for traffic coming into and leaving Derby. In 1881, Duffield Road was widened and the pavement raised on the eastern side. Decorative masonry, cast-iron bollards and attractive interlinking chains were added, which are now Grade II listed. It was named following the erection of five bracketed lamps, transferred from the Corn Market.

North Parade, a Grade II-listed terrace, is numbered 1 to 16 and is of substantial design. The land was sold to the North Parade Building Club between 1818 and 1822, when William Strutt began selling parts of his St Helen's House estate. The properties have been built in two lots of eight on a descending site, providing an extra storey at the rear. The artist of the 1917 picture of North Parade and Darley Lane is G. E. Legge. (Image Courtesy of Derby Museum and Art Gallery / www.picturethepast.org.uk)

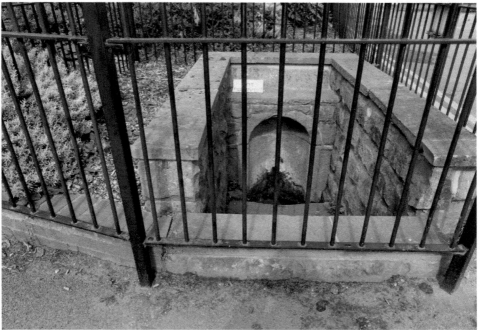

Surviving holy wells are uncommon in this country and it is surprising to find Derby's last remaining holy well situated in a built-up area well away from the city centre. St Alkmund's Well, located in Well Street, was first mentioned in 1190 but may date back much further to shortly after 800. This was the time of the dedication of the first minster church of Derby to St Alkmund, the martyred son of the king of Northumbria.

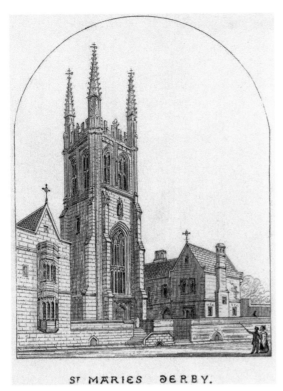

ST MARIES DERBY.

The foundation stone for St Mary's Roman Catholic Church was laid on the 4 July 1838, Queen Victoria's Coronation Day. The church itself was actually built in less than eighteen months without the aid of modern-day construction techniques, and was completed by 9 October 1839, pictured around that time. It replaced a Roman Catholic chapel and was the first major church designed by Augustus Pugin, being described as 'Pugin's Masterpiece'. A Lady chapel was added in 1853. (Image Courtesy of Derby City Council / www.picturethepast.org.uk)

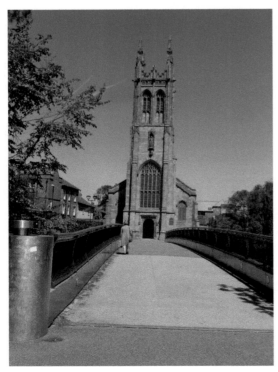

St Mary's Roman Catholic Church was built on land that once formed part of the grounds to St Helen's House, before it was sold off in building plots. Unusually, the church has been built on a north/south axis and not the traditional east/west axis. This was due to the shape of the land and Pugin was careful to point this out in a book he wrote in 1843. He also informed those who criticised him that there was no alternative.

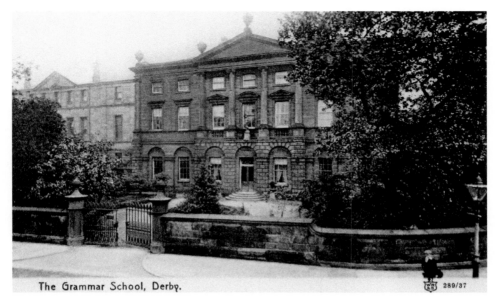

The Grammar School, Derby.

289/37

St Helen's House in King Street is a designated Grade I-listed building. It was built in 1766/7, to the design of the Derby-based architect Joseph Pickford, for Alderman John Gisborne of Yoxall Lodge, Staffordshire. In 1803, it became the home of William Strutt and his son Edward, and sixty years later of Derby Grammar School, after moving from their original premises in St Peter's Churchyard. The picture dates from around 1900. (Image Courtesy of Derby City Council / www.picturethepast.org.uk)

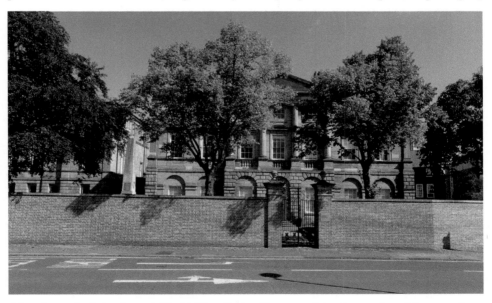

After the end of the Second World War, Derby Grammar School moved to Moorway Lane and St Helen's House was used as an art school and then for adult education. Unfortunately, the building deteriorated and closed, but it has been restored by Richard Blunt to a very high standard. On completion the developer was presented with the George Rennie Award for outstanding conservation work. Further awards followed from the Georgian Architectural Group and Derby Civic Society.

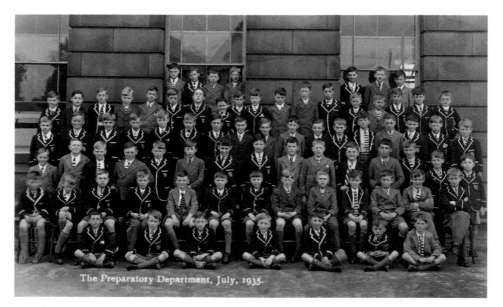

The Preparatory Department, July, 1935.

St Helen's House Preparatory Department, pictured in 1935. Following the acquisition of the house for educational purposes, additional rooms were provided to commemorate the visit of the Prince and Princess of Wales. In 1893, a chapel was added and the school playing fields extended. Games were played at Parker's Piece, a small ground on the banks of the River Derwent, and there was a boathouse for the rowing club. (Image Courtesy of Derby City Council / www.picturethepast.org.uk)

The Seven Stars Inn faces St Helen's House on King Street and dates back to the 1880s. The premises were built in 1680 but there is no record of them acting as a pub until 1775. Beer was drunk out of china tankards rather than glasses, supplied by the old porcelain works that stood nearby until 1945. Beer was brewed on the premises until 1965. It is a Grade II*-listed building.

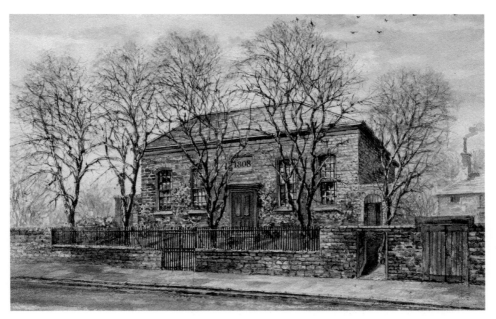

The Quakers began by holding small meetings in private rooms until numbers had grown sufficiently for them to acquire their own premises. Built in 1808, the Friends' Meeting House in St Helen's Street, pictured here in 1922, is believed to contain masonry of considerable antiquity from the old Hospital of St Helen. The name arose from George Fox, the founder of the Quakers, who bade the court at his trial for blasphemy, 'To tremble at the word of the Lord'. (Image Courtesy of Derby Museum and Art Gallery / www.picturethepast.org.uk)

In 1971, two months before it was due to officially start broadcasting, Radio Derby went on air to cover the Rolls-Royce crash from a temporary studio at Sutton Coldfield. The bankruptcy of the local aero-engine manufacturer caused consternation in Derby. In 2011, the station became the first BBC local radio station to win the prestigious 'Station of the Year' award for its category. The highly regarded station has also won several other awards.

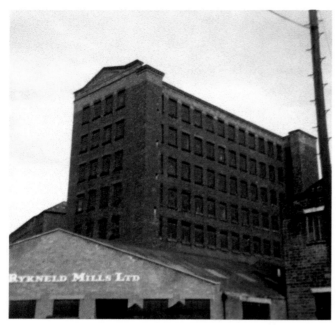

Rykneld Mill, photographed in 1970, is made up of an impressive group of silk mills that for generations found work for weavers of 'narrow fabrics', as they were once called. It is probably the most complete surviving range of nineteenth-century industrial buildings in Derby. Construction began in 1808, as a silk mill for Thomas Bridgett. Further expansion took place in 1817 and 1825, as well as late nineteenth-century additions. Listed as Grade II*, the buildings are now residential. (Image Courtesy of Derby City Council / www.picturethepast.org.uk)

The former Baptist chapel in Brook Street stood by the side of Bridgett's South Mill. Built in 1802 as Derby's first Baptist chapel, it was enlarged in 1815. By 1842, it was proving too small for the increasing congregation and moved into the converted townhouse of William Evans in St Mary's Gate. Four years later, the Wesleyan Reformers started to rent the building prior to eventual purchase. It continued as a chapel until 2002 and is now a restaurant.

Markeaton Brook played an important role in the early industrial development of Derby, providing power for a number of mills along its course. The stretch of the brook now called Brook Walk was where boats used to transport goods to and from factories along the bankside. Prior to culverting, the brook passed through Derby above ground, a foul-smelling channel of water filled with all types of obnoxious contents that created havoc when it periodically flooded. The picture is dated around 1900. (Image Courtesy of Derby Museum and Art Gallery / www.picturethepast.org.uk)

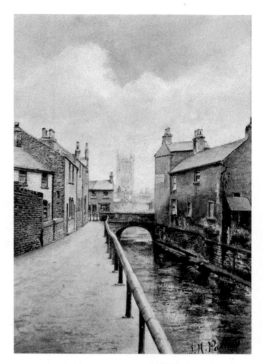

After numerous name changes, the Golden Eagle in Agard Street, first recorded in 1835, has been returned to its original name. The pub has been converted to embrace the history of the West End, with a new hand-painted sign and murals on the outside walls depicting highlights from local history. There is more historical detail inside. Markeaton Brook is to the rear, crossed by a modern bridge, provided by the University of Derby to replace a much older one.

Riverside and Little Chester

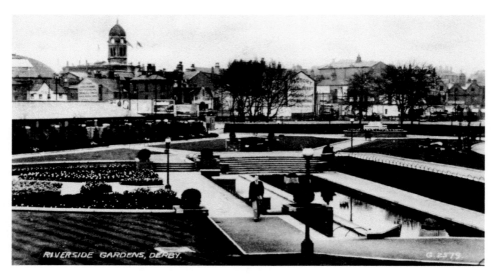

The River Gardens and Water Lily Pool are pictured in 1933, when they were opened to the public. It was several years later that the Council House was built, but the covered market on the Morledge side of the Council House was opened on 5 May 1933. The gardens have changed considerably from the original design, which included a large formal pond planted with lilies complete with two large bronze turtle sculptures, which have been transferred to Allestree Hall. (Image Courtesy of Derby City Council / www.picturethepast.org.uk)

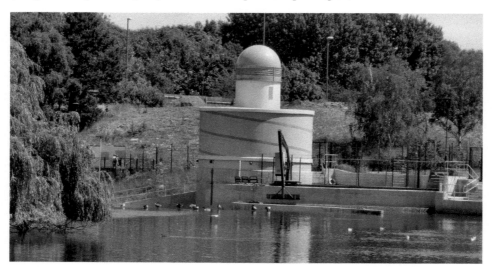

The Longbridge Hydro-Power House was opened on 20 May 2013, on the banks of the River Derwent behind the Riverlights complex. Named after the bridge that used to cross the River Derwent near the weir, the hydro exists primarily to power Derby City Council House, any surplus being sold to the National Grid. This is achieved by water being passed through a turbine to produce electricity before being returned to the river.

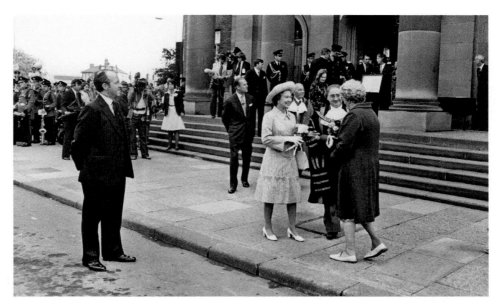

The Queen and Prince Philip outside the Council House on 28 July 1977, during her Silver Jubilee visit. The official opening of the Council House took place on the 27 June 1949, when the ceremony was performed by the then Princess Elizabeth and her husband. However, the building was not fully finished and it was not until 21 October 1954 that the council chamber was finally completed and opened, the 800th anniversary year since the granting of a market charter. (Image Courtesy of *Derby Evening Telegraph* / www.picturethepast.org.uk)

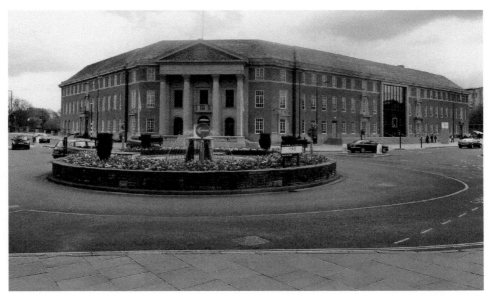

Construction of the Council House began in 1938 and was scheduled for completion in 1941, but on the outbreak of the Second World War work stopped immediately. It was allowed to resume the following year and in 1942, with the building nearly complete, it was taken over by the government for the war effort and was occupied by the Royal Air Force. They remained there until 1946.

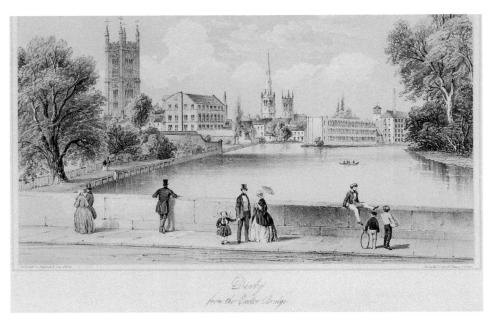

A *c.* 1800 view from Exeter Bridge looking towards the Silk Mill. It was the Bingham's of Exeter House, who built a wooden bridge across the river. As the bridge served Exeter House, it was named Exeter Bridge. After Jedediah Strutt purchased the house, the bridge was opened up to the general public, but still remained in private ownership. After Strutt's death, it was widened and later taken over by Derby Corporation and opened as a public road. (Image Courtesy of Derbyshire Libraries / www.picturethepast.org.uk)

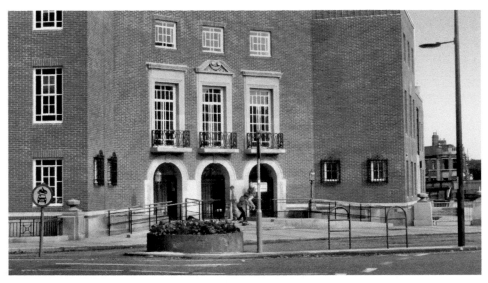

The Magistrates' Court, a Grade II-listed building, was completed in 1934 as part of Aslin's Central Improvement Scheme, which also included the Council House, the River Gardens, an open market and a bus station. A police station was also added on the northern side. In 2013, work started on the regeneration of the former Magistrates' Court to provide units for start-up businesses, a café and space for a new local studies library.

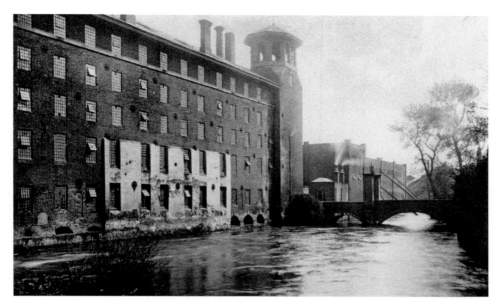

The Silk Mill is pictured *c.* 1870, looking south-east down the millstream towards the bridge on Silk Mill Lane. There was considerable demand for silk in the country at the time, but the raw materials were very expensive and had to be obtained from abroad. The method of production was a closely guarded secret by the Italians. A solution was not forthcoming, until John Lombe, one of two brothers who set up the Silk Mill, built in 1717/18, stole the manufacturing details. (Image Courtesy of Derby City Council / www.picturethepast.org.uk)

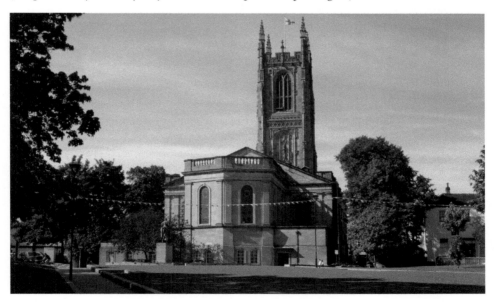

The area now known as Cathedral Green was once the home of Derby Power Station. It was built late in the 1800s, when electricity was starting to become a proven alternative to gas. It continued to increase its capacity and in 1928 the Borough Council passed a proposal for the creation of a 'super-station'. Following the change from coal to oil, the power station was demolished in the early 1970s; subsequently the area has been converted into an open space.

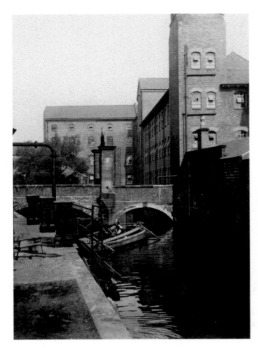

The gates on the bridge leading to the Silk Mill made by Robert Bakewell are pictured in 1920. The mill was built near the site of George Sorocold's earlier 1702 mill. It was rebuilt in 1821 and again after a fire in 1910. It was the first factory in England where all the processes were carried out under one roof and utilising one source of power. It is now part of the Derwent Valley Mills World Heritage Site. (Image Courtesy of C. B. Sherwin / www.picturethepast.org.uk)

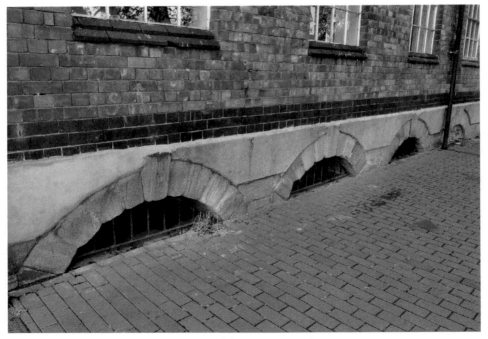

Only the carrying arches, seen in the picture, and the bell tower remain from the eighteenth-century Silk Mill. The tower acquired its present appearance after the 1821 fire, although some of the brickwork seems to be original. In 1974 Derby's Museum of Industry & History was opened on the site. Currently the museum is awaiting redevelopment, although the ground floor is still open on a limited basis.

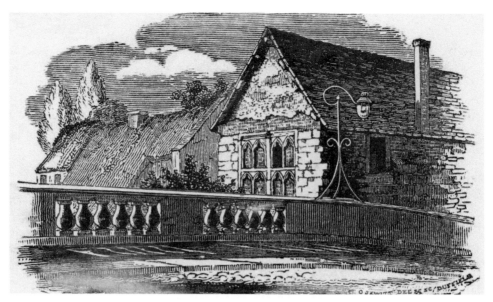

St Mary's Bridge Chapel is one of only six bridge chapels left in England. The precise date when the first bridge chapel came into existence is uncertain, but it was probably around the late thirteenth to the early fourteenth centuries, when it was built on the same site as the present chapel. This *c.* 1824 image appeared as part of an advertisement for the publication *Illustrative of the History and Antiquities of the Town of Derby* published by Stephen Glover. (Image Courtesy of Miss Frances Webb / www.picturethepast.org.uk)

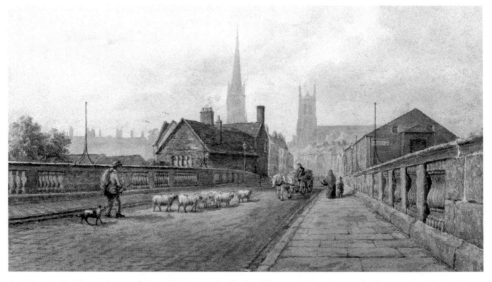

St Mary's Bridge, pictured in 1923, was built by Thomas Harrison of Chester in 1789–94 to replace an earlier bridge. It is remembered as the place where the Padley martyrs' remains were hung on the bridge outside the chapel, which at that time was serving as a gaol. They had been hung, drawn and quartered after being convicted of treason for their religious beliefs. The 'red' windows in St Mary's Roman Catholic Church show all six Derbyshire martyrs. (Image Courtesy of Derby Museum and Art Gallery / www.picturethepast.org.uk)

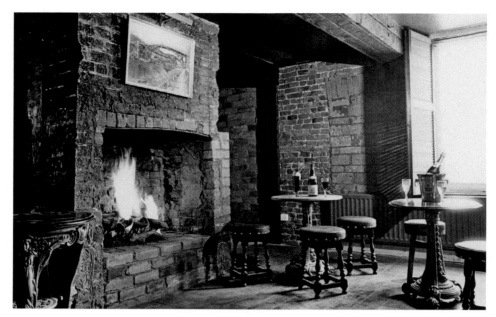

This 1985 view of the Bridge Inn (Waterside) interior shows old brickwork and an open fire. Originally a private house, the inn was established around sixty years after the property was built in the 1790s. It was always popular on Derby Regatta Days and once had a boathouse of its own. For many years an old penny-farthing bike was fixed to the top of the wall near the rear entrance. (Image Courtesy of *Derby Evening Telegraph* / www.picturethepast.org.uk)

Arthur Thomas Barlow was a particularly notable member of the Methodist chapel. After he had undergone treatment at the Derbyshire Royal Infirmary, he was so appreciative of the care provided he worked tirelessly for the rest of his life arranging concerts to raise funds for the hospital. Gracie Fields featured in one concert and he even persuaded a member of the royal family to act as a patron. The chapel celebrated its 100th birthday on 25 October 1987.

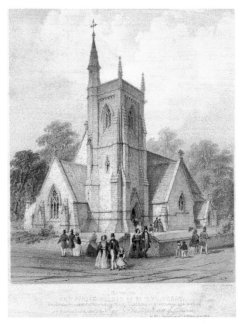

By the mid-1800s the population of Little Chester had increased to over 500 people. To meet the growing demand St Paul's Church was built, pictured in a hand-tinted lithograph of that date. It was constructed mainly of Little Eaton Quarry stone and is now Grade II listed along with the war memorial, which is classed as an ancient monument. The church was consecrated on the 22 May 1850, when it replaced a mission room on City Road. (Image Courtesy of Derby City Council / www.picturethepast.org.uk)

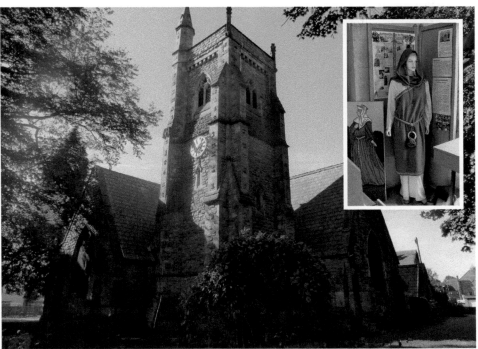

Little Chester Heritage Centre is located in St Paul's Church. For anyone interested in the local history of Derby and the Roman fort at Derventio, a visit to the centre is essential. It is normally open on Sunday afternoons from April to October from 2–4.30 p.m. Volunteers from the Local History Group staff the centre and will be happy to arrange for group visits and guided walks when the centre is not open (telephone 01332 363354).

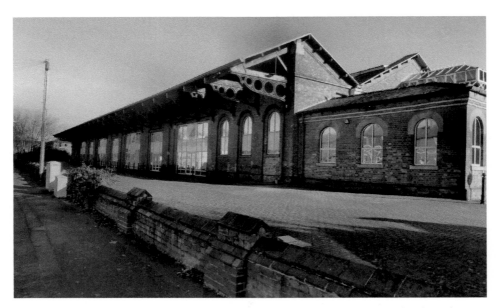

Less than ten years after it opened, Derby railway station became very congested and goods trains in particular experienced long delays. In order to help rectify this situation a large goods station was built adjacent to St Mary's Bridge, where an extensive wharf was established. The goods branch opened in 1855 and a few years later more land was acquired and the facilities expanded. The freight depot (pictured) still remains, together with a few other old railway buildings.

Chester Green, seen here in 1990, has been in existence as an area of open space since the Middle Ages. In the past it was a rough place and some families would not let their children go near it, although others used it for sport and recreation as well as occasional meetings. One of the problems was it was poorly drained and regularly flooded. The green was re-laid in 1882 and it became an important venue for sport and celebrations.

In 1968, some of the remains of the Roman settlement called Derventio were revealed following the removal of the railway line and embankment. Two wells were discovered and the local authority decided to preserve the one at the end of Marcus Street, together with a number of post holes that had also been discovered. The well was first dressed in 1980, the event taking place during the spring bank holiday. Recently the event has been discontinued.

Experienced well dresser and prominent historian Derek Palmer from Chaddesden was enlisted to lead the team of dressers and the Marcus Street well was dressed for the first time in 1980. A year later permission was obtained to dress the well in the vicarage garden. The picture shows Derek Palmer putting the finishing touches to a well dressing in 1990. Well dressing is not quite unique to Derbyshire, but it is the county where the tradition is the strongest. (Image Courtesy of *Derby Evening Telegraph* / www.picturethepast.org.uk)

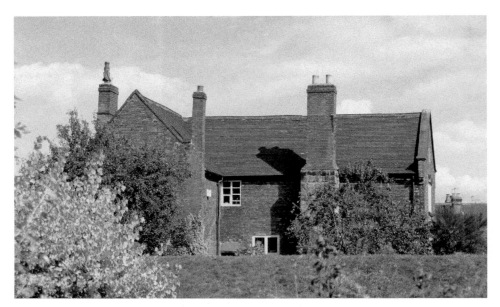

Stone House Prebend, also known as School Farm, is located at the end of Old Chester Road facing the River Derwent. Formerly it was a timber-framed building, the income from the farm supporting the canons of the College of All Saints until 1549. It is probably the oldest domestic property in Derby. Parts of the building are medieval, including a huge exterior chimney breast; the remainder is late sixteenth to early seventeenth century. (Image Courtesy of Derby City Council / www.picturethepast.org.uk)

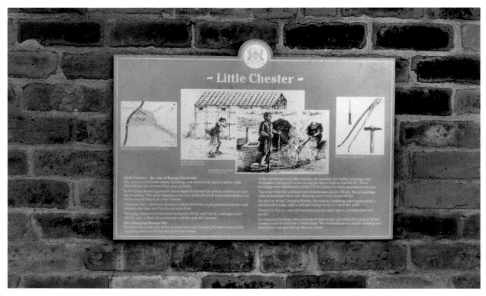

Pictured is the information board at the junction of Old Chester Road and City Road that tells the story of the fortified settlement of Derventio, which was built by the Romans. The Roman occupation did not limit itself solely to the fort at Derventio and the area directly outside. Recent excavations have revealed the existence of an industrial site and burial ground on the edge of the Old Derby Racecourse and other scattered finds, including a farm at Willington.

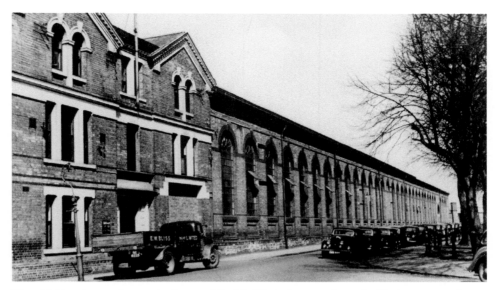

This 1950s picture shows the front of E. W. Bliss's factory, formerly Haslam's Foundry & Engineering Co. Haslam's Foundry was established in the 1860s by Alfred Haslam, whose father William was a whitesmith and bell-hanger of St Peter's Street. The company was initially engaged in heavy engineering, but later specialised in the manufacture of refrigeration equipment. Haslam's firm monopolised the ship refrigeration business until 1894, also supplying many land-based operations with refrigeration units, including docks, hospitals and hotels. (Image Courtesy of Derby City Council / www.picturethepast.org.uk)

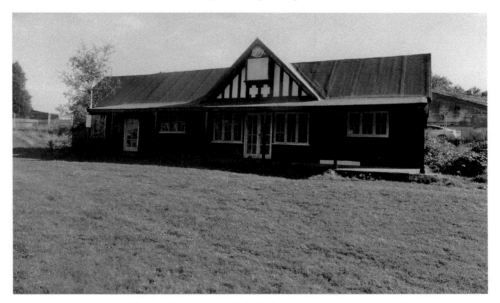

Little remains at Little Chester above ground of the Roman occupation, apart from two Roman wells. A series of excavations, however, in the last sixty years have established both its importance and prosperity, including the discovery of an underfloor heating system on Parker's Piece (pictured) and an abundance of coins. In more recent times Parker's Piece was used by Derby Grammar School as a playing field.

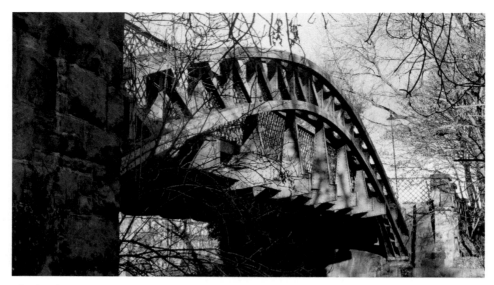

The fine bowstring bridge that crosses the River Derwent, behind Haslam's factory, was built by Andrew Handyside in 1877 and named after him. It formerly carried the Great Northern Railway's Nottingham–Derby line between North Parade and City Road, and remained in use until closed by Dr Beeching. The original public footway along the near side of the structure has been removed. Since then, pedestrians have used the main span, walking where the tracks were once laid.

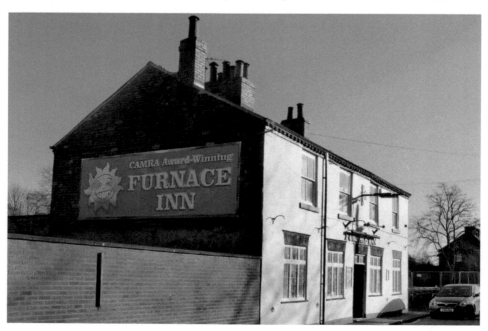

The Furnace Inn took over its present premises at the end of the nineteenth century, where part of Andrew Handyside's Britannia Foundry once stood. Handyside established his Britannia heavy engineering works and iron foundry in 1848 and although originally producing ornamental and architectural ironwork, he later became involved with railway architecture and constructed the bridge over the Derwent. In 2014 the Furnace was named winner of the 'Pub of the Year' by Derby CAMRA.

This picture was taken prior to
the rebuilding of St Michael's
Church in 1857/58, following
the collapse of the east gable.
A church has stood on the site
since the Domesday Book, but
it finally closed in the 1970s. In
the seventeenth and eighteenth
centuries the churchyard
contained the cistern to George
Sorocold's ingenious system of
providing drinking water to the
townspeople of Derby. The water
from the cistern was circulated by
gravity around the town in elm
pipes. (Image Courtesy of Derby
City Council /
www.picturethepast.org.uk)

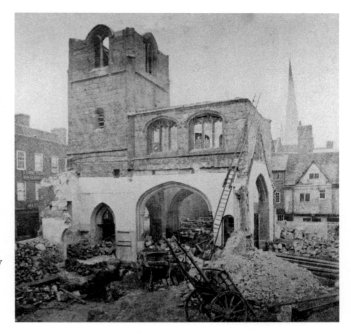

Number twenty-seven Queen
Street was built in the 1600s
by Stephen Flamsteed, father
of astronomer John Flamsteed,
who inherited it in 1688. It was
refronted by Joseph Pickford
in 1764 for his friend, the
philosopher and clockmaker,
John Whitehurst. Both artist
Joseph Wright and Astronomer
Royal John Flamsteed lived
there, which is commemorated
by a blue plaque. Later it was
divided, the left part becoming
the Acorn Vaults, and the other
side the Clockworks.

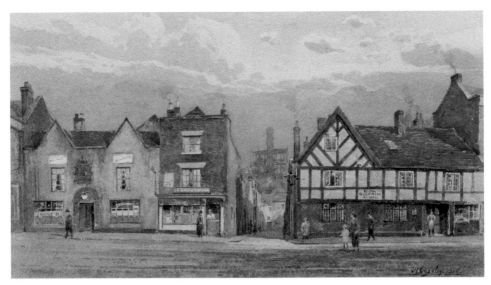

Derby's oldest surviving pub, The Dolphin, claims to have been founded in 1530. The Dolphin was a well-known Christian symbol in medieval days, which gives credibility to the presumed date of the founding of the pub. It is a fine example of an old timber-framed coaching inn, which it is said to have been a stopping-off place for highwaymen, including Dick Turpin. The pub's eighteenth-century extension at the rear was originally a doctor's house. (Image Courtesy of Derby Museum and Art Gallery / www.picturethepast.org.uk)

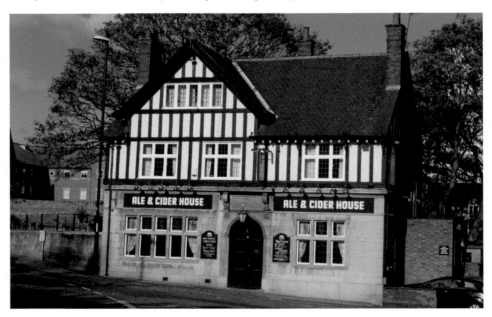

The first records of the existence of the Old Silk Mill pub by name are dated 1874, but it is likely that it goes back much further. It was demolished in 1924 and replaced on a slightly different site by the present half-timbered building. A mural takes up the whole of one of the external walls. It was painted in 1986, depicting the Silk Trades' lockout of 1833/4, when hundreds of newly joined trade unionists found themselves locked out.

London Road and Railway Quarter

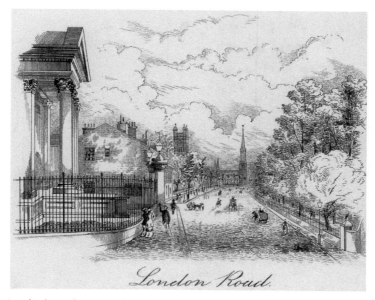

London Road.

A *c.* 1880 view looking down London Road from the Congregational church, with Holy Trinity and St Andrew's Church in the distance. In 1738, a Turnpike Trust was set up by Parliament, authorised to collect tolls in return for maintaining the road to London, which considerably improved the speed of movement. The importance of London Road grew with the arrival of the railways in the town, with access to the railway station facilitated by the building of Midland Road in 1840. (Image Courtesy of Derby City Council / www.picturethepast.org.uk)

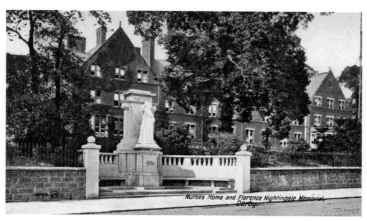

Nurses Home and Florence Nightingale Memorial Derby

An early 1900s picture of the Florence Nightingale's Memorial and Nurses Home. It was the measures she took to save the injured during the Crimean War that made her famous and she became a legend in her own lifetime. Born in Italy in 1820, she divided her time between family homes at Lea Hurst, Derbyshire, and Embley, Hampshire. When it was discovered that the Derby Hospital ventilation ducts could not be properly cleaned, causing increased death rates, she advised on its rebuilding. (Image Courtesy of Derby City Council / www.picturethepast.org.uk)

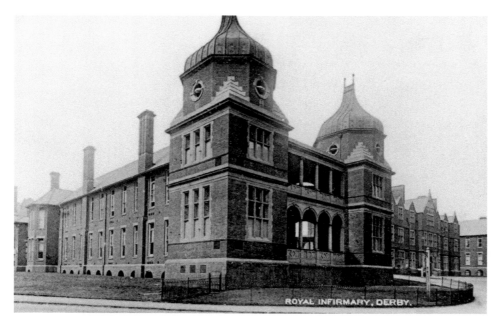

Derbyshire General Infirmary, pictured *c*. 1904, was built following a public subscription. William Strutt, a descendant of Jedediah, the famous industrialist, incorporated many revolutionary designs into the new hospital. These included a hot-air plant for heating and ventilation and numerous other labour-saving devices. Unfortunately, no proper solution could be found to clean the ventilation ducts, which caused disease and an above average death rate. This led to the rebuilding of the hospital. (Image Courtesy of Derby City Council / www.picturethepast.org.uk)

The Liversage Trust Almshouses were built out of part of the proceeds of the Liversage estate. Robert Liversage, a master dyer and tradesman, had become very wealthy during the first half of the sixteenth century, but died childless in 1529 along with his wife. They left all their land and property to the poor of St Peter's Parish. This led to the establishment of the Liversage Charity Trust, the value of which increased enormously over the years.

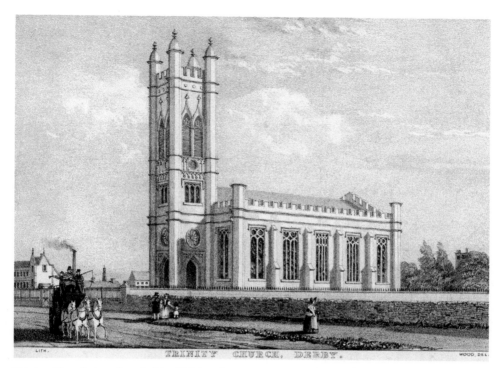

Trinity Church was founded in 1836 and was originally a chapel of ease to St Peter's Church in the centre of Derby, licensed for baptisms and burials. Worship continued until 1972, when the parish united with Christ Church on Normanton Road, and the London Road church was closed. In 1973, the church was saved from demolition when it was purchased by the Assemblies of the First Born, which had been established in the 1960s. The engraving is dated 1836. (Image Courtesy of Derby City Council / www.picturethepast.org.uk)

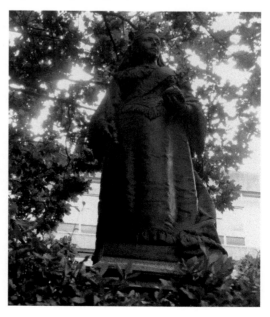

In 1925, Queen Victoria's statue was moved to the grounds of the former Derby Royal Infirmary from The Spot, where it had originally stood since being unveiled by her son Edward VII on 28 June 1906. Queen Victoria made her only state visit to Derby in 1891, when she laid the foundation stone of the new Derbyshire Royal Infirmary and knighted the mayor, Alderman Alfred Seale Haslam, who had donated the bronze statue.

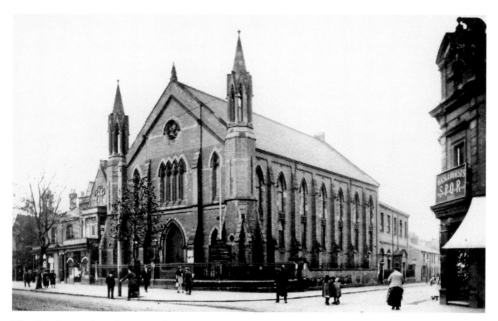

The Wesleyan chapel, pictured *c*. 1920, opened in 1861. The manse next to the chapel was replaced by the Queen's Chambers. In total the complex had more than 100 rooms, including three halls and the church. In 1927 it also had a school with places for over 1,000 pupils. During the Second World War a bomb fell on Canal Street, destroying the rear corner of the building, which was rebuilt with a curved frontage. It is now a banqueting and conference centre. (Image Courtesy of Derby City Council / www.picturethepast.org.uk)

Royal Visit to Derby, Decorations in Station Street. Scott Series 105

Crowds and troops lined up along Midland Road on 28 June 1906, awaiting the arrival of Edward VII on his visit to Derby to unveil the statue of his mother, Queen Victoria, at The Spot. Occupying a prominent corner position at the junction of Midland Road with London Road is the Crown & Cushion public house. It was built in 1853, no doubt with the intention of benefiting from the boom created by the arrival of the railways. (Image Courtesy of Derby City Council / www.picturethepast.org.uk)

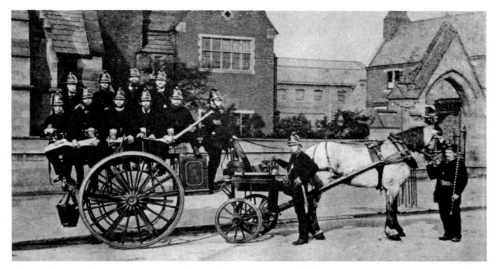

The Litchurch fire engine is pictured outside St Andrew's Church on London Road in 1880. Built in 1866 by Sir George Gilbert Scott, the church survived until 1970, when it was demolished along with St Andrew's School and replaced by St Andrew's House. Always regarded as the railwaymen's church, St Andrew's dominated the skyline of London Road. The Midland Railway contributed generously towards its building costs to ensure that the spiritual needs of its workforce were met. (Image Courtesy of Derby City Council / www.picturethepast.org.uk)

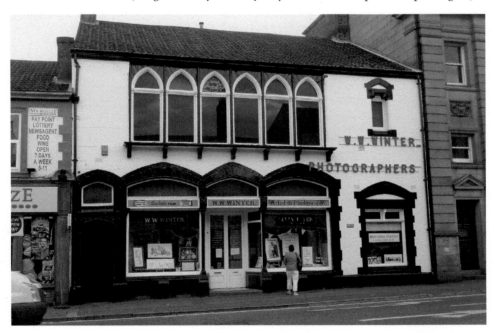

Winter's is recognised as one of the oldest photography studios in the world, with its origins dating back to the 1850s when Emmanuel Nicolas Charles established a photographic studio in Midland Road. Following his death in 1864, the studio was taken over first by his wife, and then by his former assistant, Walter William Winter. Three years after taking over the business, Winter had it moved across the road to take better advantage of the sunlight.

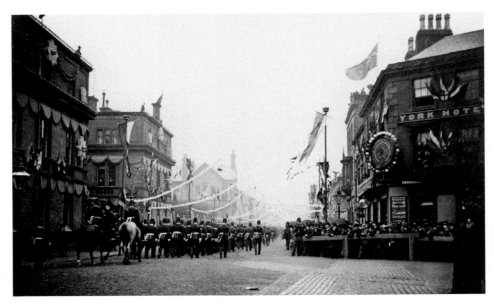

This picture shows troops on parade and policemen lined up in front of the crowds on the 21 May 1891 to mark the occasion of Queen Victoria's visit. The Midland Hotel (Hallmark) is on the left. Built to a high standard, it was the first purpose-built railway hotel in the country, and is still one of the finest in the city; it was intended for first-class rail passengers. Many famous people have visited the hotel, including Gracie Fields at the height of her career. (Image Courtesy of Derby City Council / www.picturethepast.org.uk)

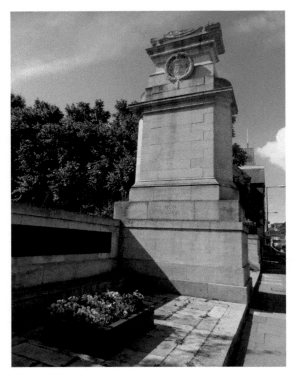

The Railway Cenotaph was designed by Sir Edwin Lutyens, who also designed the cenotaph on Whitehall in London. It was erected in 1921 to commemorate the Midland Railway employees that lost their lives in the First World War. The names of the dead were inscribed on the memorial and also published in a commemorative book. A copy was sent to the families of the dead along with a free travel pass to visit the memorial.

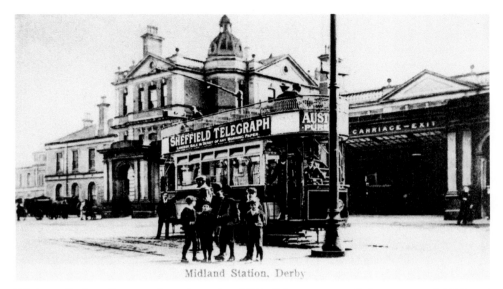

Midland Station, Derby

Work on Derby railway station, pictured *c.* 1910, did not start until the autumn of 1839 and temporary arrangements were made for the intervening period between the commencement of railway services and the completion of the station. It was built by Thomas Jackson, designed by Francis Thompson, and paid for by the North Midland Railway. The other two railway companies who also operated from the site were charged rent. It was completed during the summer of 1840. (Image Courtesy of Derby City Council / www.picturethepast.org.uk)

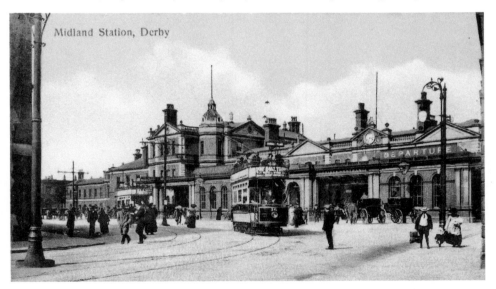

Derby Corporation electric tramcar No. 16 is pictured in front of the Midland railway station in this pre-1910 image. The station slowly deteriorated over the years and although improvements and repairs were undertaken periodically, the main station buildings were urgently in need of costly repairs, so the decision to demolish it was taken. Plans for a new modern station were drawn up and work began in December 1985. Further improvements have been carried out to improve the station and customer experience. (Image Courtesy of Derby City Council / www.picturethepast.org.uk)

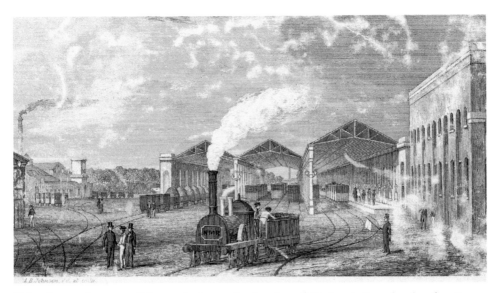

This nineteenth-century lithograph shows the interior of Derby station shortly after it was completed in 1840. The three train sheds take up the centre of the picture, with the Midlands Counties Railway's platform on the right and the locomotive workshops of the North Midland Railway on the left. Cutthroat competition and the lack of collaboration between the three railway companies was solved by the formation of the Midland Railway on 10 May 1844. (Image Courtesy of Derby City Council / www.picturethepast.org.uk)

The redevelopment of the railway station in 1985 necessitated the demolition of the old station, but the station clock and its surround were saved and moved to the end of the Railway Terrace car park. It is mounted on a plinth at the side of Wyvern House. Following the amalgamation in 1844 of the three companies operating from the station and the formation of the Midland Railway, a new coat of arms was created for the enlarged company.

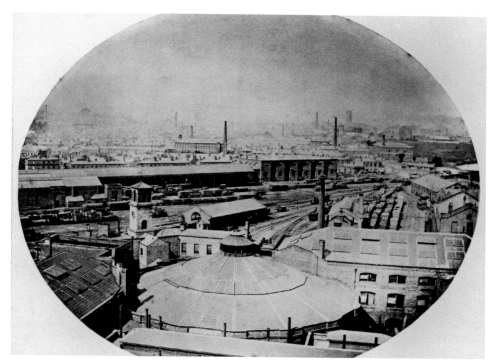

This is aerial view from *c.* 1900, taken from the roof of Midland Counties Railway, clearly picks out the Roundhouse. It is the world's first and oldest surviving railway roundhouse. The site with its storage sheds and historic locomotive turntable had been deteriorating, since it was for the most part vacated in 1990. After several plans failed, it was superbly restored by Derby University and is once again something that Derby people can look up on with great pride. (Image Courtesy of Derby City Council / www.picturethepast.org.uk)

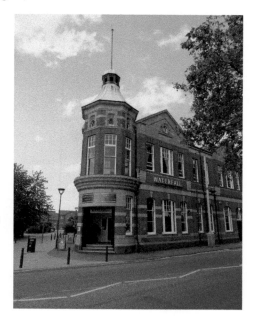

The Waterfall opened as a public house in 1996 in the former Midland Railway Institute Building, which was built in 1892. In the years following the setting up of the pub, it has been refurbished to include a bar and café, an American pool lounge, two function rooms and an executive bar. It caters for weddings, anniversaries, christenings and various types of parties.

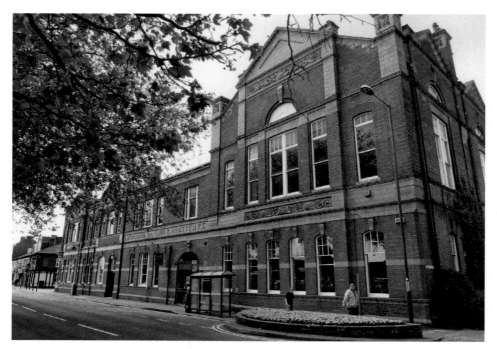

Ten years after the arrival of the railway, the Railway Institute was founded for Midland Railway employees. The impressive red-brick building was erected in 1892, with its name spelt out in terracotta facing bricks, looking onto Railway Terrace. Opened on 16 February 1894 as a cultural centre for railway workers, at one time it contained a library of 18,000 books, a concert hall with a stage and seating for 500 people, along with several other rooms.

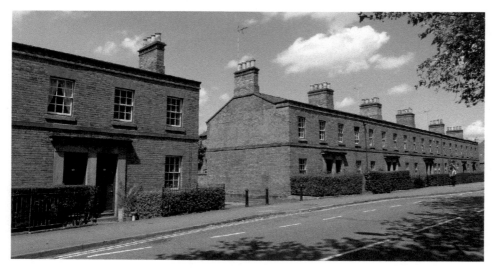

In order to accommodate the more senior Midland Railway staff, Jackson and Thompson built a triangular block of streets called North Street (now Calvert Street), Midland Place and Railway Terrace. The initial letter from the three streets forms the initials NMR, which stands for North Midland Railway. All the railway cottages are still occupied, following a successful campaign in the 1970s against demolition.

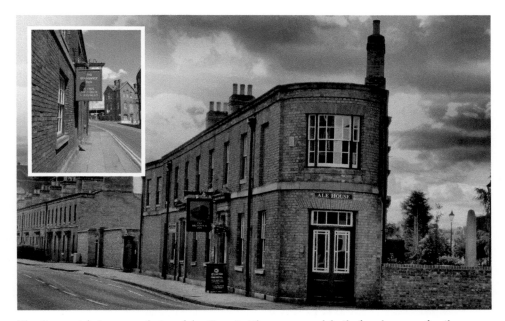

The Brunswick Inn was designed by Francis Thompson and built for the use of railwaymen and second-class passengers. It opened in 1842 and is one of, if not the earliest, examples of a purpose-built commercial inn in the country. Originally it was called 'The Brunswick Railway and Commercial Inn' and remained in the ownership of the railways for 105 years. After lying derelict for some time, it was rescued from the threat of demolition and restored.

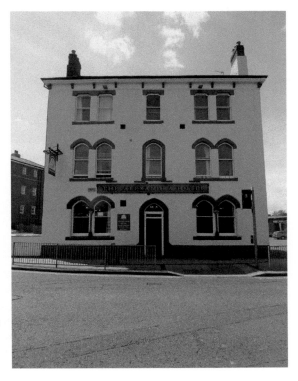

The Alexandra Hotel, near the new Pride Park flyover, was built around 1890. The award-winning pub is named after HRH Princess Alexandra, the Danish princess who married the future Edward VII on 10 March 1863. In 1974 it became the birthplace of Derby CAMRA (The Campaign for Real Ale), but despite this was closed for demolition in 1987. For two years it remained boarded up before being rescued by Bateman's Brewery.

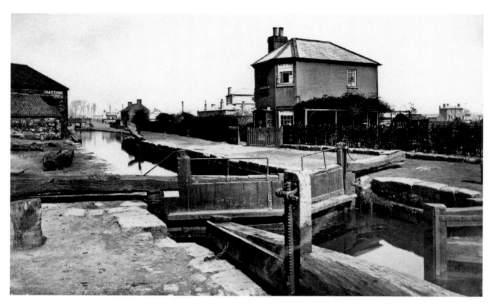

The locks and lock house of Derby Canal are pictured in 1793, near where Siddalls Road now runs. Commissioned in 1793, the canal ran 14 miles from the junction of the Erewash Canal to meet the Trent & Mersey Canal at Swarkestone. The bridge wall by the road between the Alexandra and the Brunswick Inn identifies where a branch of the former Derby Canal once ran to provide waterborne services to industries in the Wellington Street area. (Image Courtesy of Derby City Council / www.picturethepast.org.uk)

Michael Thomas Bass, MP for Derby from 1848–83, gave the land to the town in 1867, on which the Bass Recreation Ground now stands. The 3-acre site bounded by the River Derwent and Morledge millstream was formerly known as 'The Holmes'. In 1866 it became Derby's second park. The open-air swimming baths on the site comprised two baths, measuring 100 feet by 50 feet with 129 dressing cubicles.

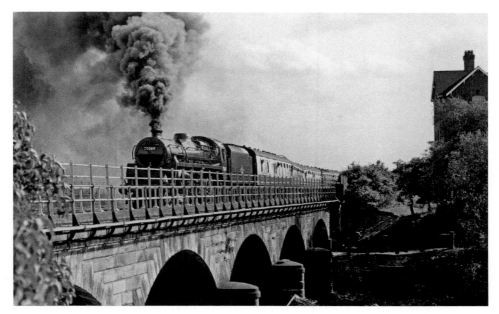

Pictured in 1987 is steam locomotive 75069 crossing Five Arches Bridge. The bridge over the River Derwent ran to the north of the railway station and dates back to 1839. It was paid for by the North Midland Railway and still remains in use today. The girder bridge over the former Derby Canal, paid for by the Midland Counties Railway, is now dominated by the modern road viaduct carrying Pride Parkway over the line. (Image Courtesy of David Birt / www.picturethepast.org.uk)

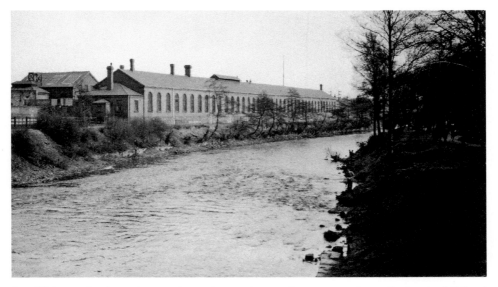

In addition to having a locomotive and a carriage and wagon works at Derby, the Midland Railway also established a signal works in 1871, pictured *c.* 1948. It was located on a narrow strip of land between the Derby–Sheffield main line and the River Derwent, north of the station. Closure came in 1932, with production transferred to Crewe, but the buildings survived until the early 1970s. *Derby Evening Telegraph* moved to the site in 1979, leaving in 2014. (Image Courtesy of Derby City Council / www.picturethepast.org.uk)

Derby County's impressive stadium forms the centrepiece of the Pride Park development. It could have been very different as, after making plans to move to Pride Park, the club decided to stay at the baseball ground. In a dramatic last-minute move, with work scheduled to start on the baseball ground within days, the club had second thoughts and reopened talks about moving to Pride Park. The stadium was opened by Her Majesty the Queen on 18 July 1997.

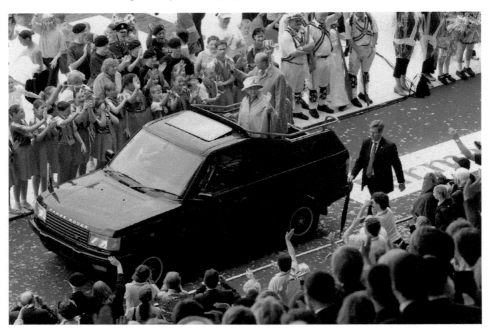

The picture shows the Queen and Duke of Edinburgh about to leave Pride Park Stadium, home of Derby County FC, on 1 August 2002, after her Golden Jubilee celebrations. Despite heavy rain, a crowd of more than 27,000 had gathered early for a spectacular pageant, featuring 2,000 performers from the county, who not only celebrated the Queen's fifty years on the throne, but also Derby's 25th anniversary as a city. The event was compered by Buxton-born Goodie, Tim Brooke-Taylor. (Image Courtesy of *Derby Evening Telegraph* / www.picturethepast.org.uk)

Chaddesden Sidings, pictured 1961, are sited in a relatively flat, shallow valley, ideal for the purpose for which they were intended. Eventually they fell out of use and the vast expanse of railway land now known as Pride Park became derelict. The land was badly contaminated and required extensive redevelopment, which took over ten years to reclaim. During the last twenty years Pride Park has developed into one of the most important business and commercial property destinations in the region. (Image Courtesy of Derbyshire Libraries / www.picturethepast.org.uk)

Derby Arena, located at Pride Park, is a multi-use arena and velodrome, suitable for sporting events as well as exhibitions, concerts, product launches and conferences. It is able to accommodate up to 5,000 people for special events, with some seated and others standing. The 250-metre indoor cycle track is appropriate for individual, club, school, group and business track sessions, track leagues, and local, regional, national and international track events. Café 42 is an excellent place to take refreshment.

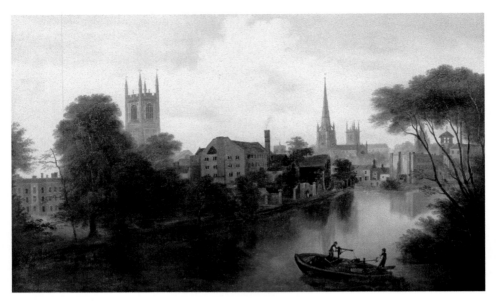

The first Exeter Bridge, pictured in 1838, was called 'Short Bridge'. On the extreme left is Exeter House. The house was built *c.* 1635–40 with later Georgian additions. It was named after Lord Exeter, who owned it in the early eighteenth century.

About the Author

Denis Eardley has been writing local interest features and walks for the *Derby Telegraph* for twenty years. He has compiled eleven *Discover Derbyshire* and two *Discover Derby* supplements, as well as writing for *Yesterday Today* and the award-winning *Derbyshire Magazine*. Denis also supplies the *Derby Telegraph* with weekly town and village profiles as well as walks, which are published during the spring and summer each year.

Denis lives in Derby and enjoys sport, photography and visiting towns, villages and the countryside in the UK with his family, which now includes two grandsons. He has written five books: *Around Wirksworth, Wirksworth and the Surrounding Area, Villages of the Peak District, Derwent Valley Walks, Derwent Valley Mills World Heritage and Picture the Past Derby.*